BY CAROLE KATCHEN

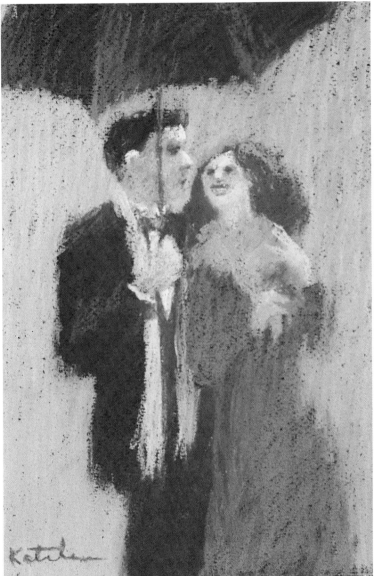

express yourself!

WITH PASTEL

international artist

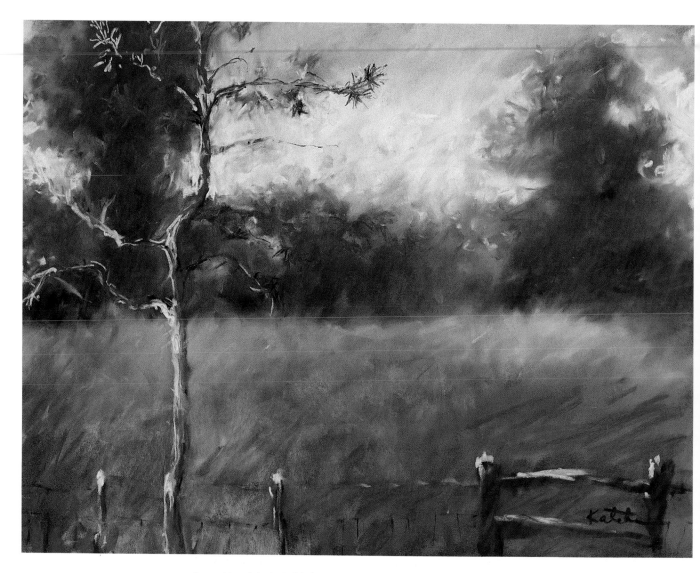

International Artist Publishing, Inc
2775 Old Highway 40
P.O. Box 1450
Verdi, Nevada 89439

Design by Vincent Miller
Typeset by Ilse Holloway
Edited by Jennifer King
Managing Editor Terri Dodd

Library of Congress Cataloging-in-Publication Data
Katchen, Carole, 1944-
 Express yourself with pastel / by Carole Katchen.
 p. cm.
 ISBN 1-929834-07-1
 I. Pastel drawing–Technique. I. Title.

 NC880 K383 2000
 741.2'35–dc21 00-061337

Printed in Hong Kong
First printed in paperback 2001
05 04 03 02 01 5 4 3 2 1

Distributed to the trade and art markets
in North America by

North Light Books,
an imprint of F&W Publications, Inc.
1507 Dana Avenue
Cincinnati, OH 45207
(800) 289-0963

Dedication

This book is dedicated to Hot Springs, Arkansas, City of the Arts. Thank you for embracing the arts with your attention and with your pocketbooks. It is a privilege to call Hot Springs my home.

Special thanks to all the people without whom this book would not have been possible: Ken and Bev Barry, Cindy Momchilov and Janet Smith at Camera Work, Mac and Ann Caruso, John Gaudin, Marian Hirsch, Linda Katchen, Sue Kent, Pawel and Irmgard Kontny, Rhonda at Kwik Print, Jo Ann Leiser, Mara Magdalene, Alex McDonald, Ricky Medlock, Ernest and Rosemary Nipper, Ann Nusko, Kay Polk, Richard and Laura Rosenberg, Urania Christy Tarbet, all of my dealers, and, of course, Jennifer King and Vincent Miller.

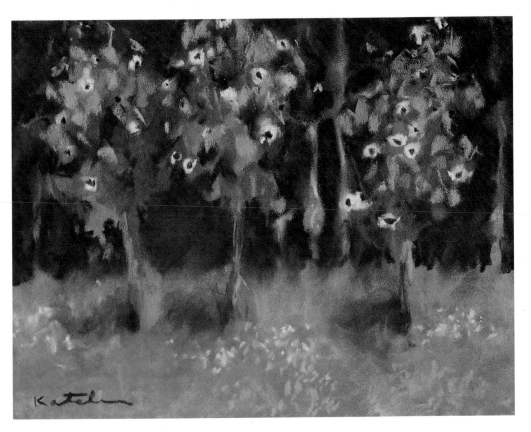

"Sunflowers Gone Wild",
9 x 12" (23 x 31cm)

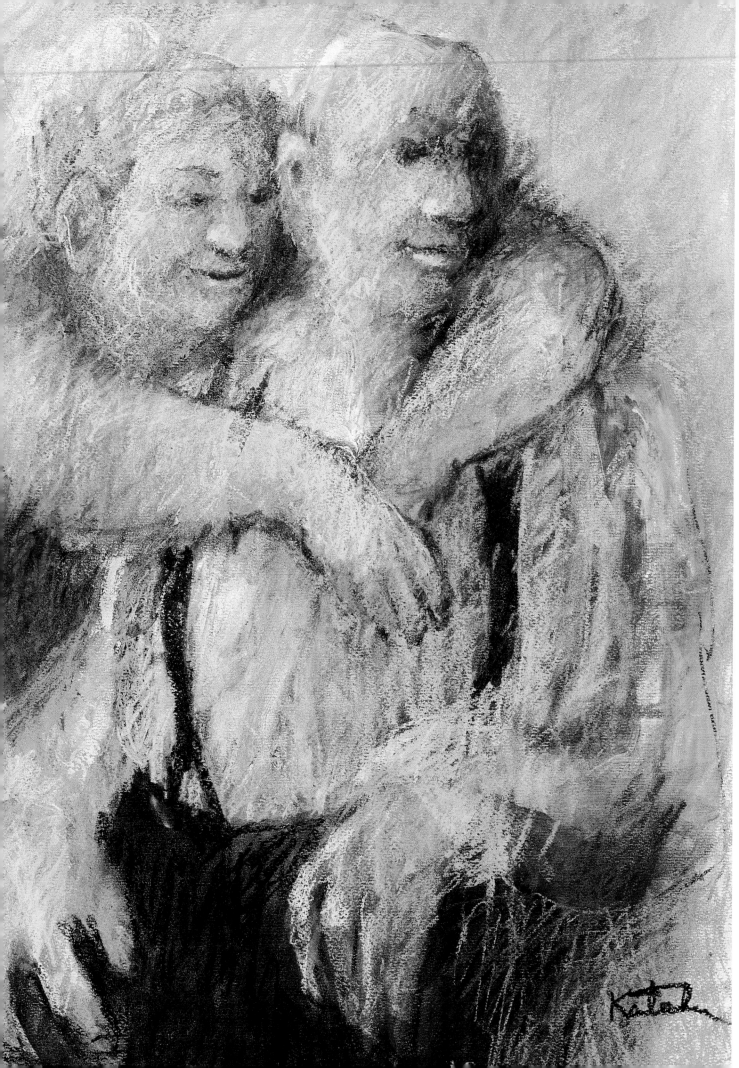

Preface

Pastel, the most expressive medium in the hands of creative artists, is currently experiencing a worldwide renaissance. Its versatility and beauty have been touted by many over the years. Unlike other media, it gives the artist total control for creative expression and is capable of a wide range of interpretation, lending itself to any subject matter. Many books have been written on the merits of pastel, and now in her timely fashion, my good friend and colleague, Carole Katchen, has written and illustrated one of the most innovative books on the subject of pastel.

Express Yourself with Pastel brings an exciting new concept and challenge to all artists who wish to explore the outer limits of their creative powers. The book offers good advice to beginners through advanced artists. Using the luminous medium of pastel, the author demonstrates her unique approach to both drawing and painting, sharing control methods that are so valuable to all artists.

Carole has the great ability to capture the insight of personalities that cross her life each day, and each person she encounters becomes a potential painting. She helps you view the world through her eyes and mind, showing you the world is yours to place on canvas in your own creative approach. It is obvious the author has an exciting command of her unique pastel techniques, and she invites you to walk the path of creativity with her.

Urania Christy Tarbet
President, International Association of Pastel Societies

**"The Best Years",
27 x 19" (69 x 48cm)**

Contents

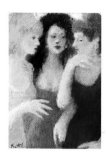
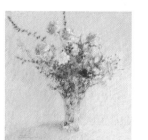

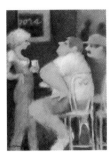
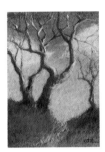

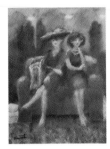
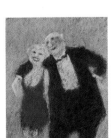

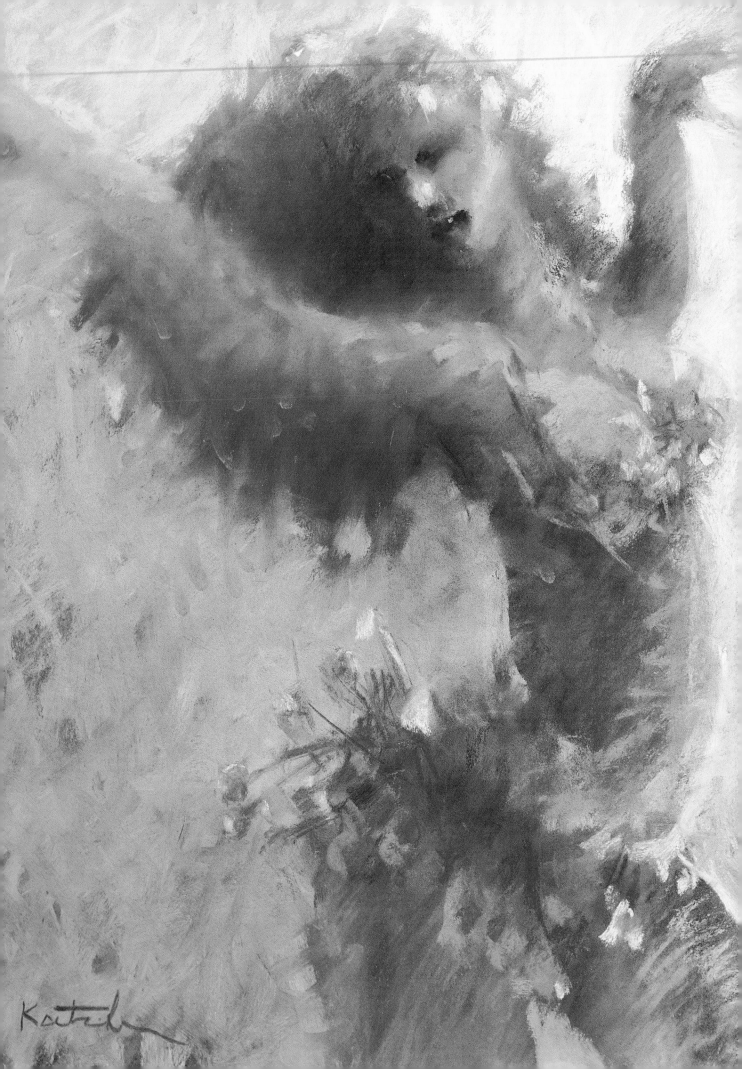

Introduction

SPEND SOME TIME WITH PASTELS, AND YOU'LL FIND IT THE IDEAL MEDIUM FOR EXPRESSING YOUR PERSONAL VISION.

The case for self-expression

The greatest thing about painting, for me, is the opportunity to find and express my own personal vision. Through the unlikely process of dabbing color onto a flat surface, I continually explore my relationship to the world. Beyond words, art touches and reveals the most inarticulate parts of myself. It is always exciting, challenging, sometimes even a bit frightening.

And art expands my world. Surrounding myself with other people's art, I become sensitive to colors, shapes and moods that I've never seen before. I can look at a painting 400 years old and, because I see the world through that artist's eyes, I become part of that world.

Of course, I know artists who studied with a powerful teacher early in their career. After many years, they still paint in the style of the teacher, creating image after image from their teacher's world. Other artists slavishly copy photographs from magazines and other sources unrelated to themselves. For me, these people are missing out on the greatest joy of being an artist — discovering and sharing their own view of the world.

Embrace your personal vision

Self-expression has always been highly prized in Western civilization. In fact, the United States was predicated on freedom of expression. In US schools, every child is taught the legend of the first colonists leaving England in quest of religious freedom. Throughout the history of my country, explorers have been rewarded for pursuing new frontiers. Today, when all of the land has been claimed, Americans charge into new technological frontiers.

It's not necessary to be an adventurer, but I believe that is what gives life its zest. The life of a professional artist is fraught with challenges, frustrations and disappointments. What keeps me going in the hard times is the possibility that my next painting will be totally new and fabulous. Maybe next time I will be able to say something that never has been said before. Maybe next time I will be able to show people who I am and what my dreams are.

Does this sound egotistical? It is. I make no apologies for my ego. I believe that the greatest gift I have to offer the world is the uniqueness of my vision.

I have heard it said that there are no new paintings, that everything has already been done. Mostly I've heard this from critics and "avant garde" painters justifying their own lack of knowledge of traditional painting techniques. Yes, there are new paintings. Our world changes every day, as does our consciousness. Even when we paint subjects that have been explored many times in the past, we are bringing them into a new context. Lately I have been painting pictures of formal ballrooms with men in tuxedoes and women in long gowns. These are not the people of Impressionist Paris. The costumes might resemble a previous era, but the conversations, frequently conveyed through the body language, are absolutely current.

Dare to be different

Unfortunately, there is a cost for self-expression. Like so many things that are praised and valued in the abstract, the act of expressing yourself can be disturbing to other people. I am reminded of my

Making expressive marks
What makes this dancer in "Flight of Fancy" (25 x 19" or 64 x 49cm) seem like she is moving is the lively surface texture. Look at the wonderful variety of strokes and textures in this painting. With pastels, you can make any kind of mark that you can imagine. The reason pastels are so good for expressing yourself is that you can do just about anything with them.

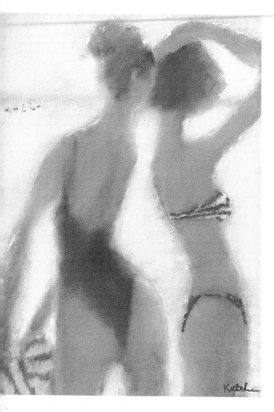

Staying honest

Self-expression is not always popular. "Beach Birds" (25 x 19" or 64 x 48cm) was rejected from a members' exhibit of the California Art Club. The reason? It wasn't like the other paintings in the show. At the time, I was disappointed but at this point in my career, I would rather be remembered for being an honest, imaginative painter than for being popular.

"beach bird" paintings. I was living in Southern California at the time, spending a fair amount of time on the beach. I was fascinated by the saucy sunbathers in bikinis parading along the seashore. So, using figure studies as reference material, I painted several of the girls in that environment. I was delighted with the paintings. I thought I had done a good job with the anatomy as well as capturing the gestures and beach ambiance.

However, when I delivered them to a membership show of the California Art Club, I was told they couldn't hang in the show. No one had a reason other than they didn't fit in with the more classical landscapes that other painters had brought. That is the danger of expressing yourself — you might not fit in.

For years, that was very important to me. I wanted to fit in. I wanted to fit in with other artists, with galleries and collectors. I painted what I thought was "normal", but over and over again my work was rejected for being too different. Now that I am a well-established artist, people praise my work just because it is different. Whether I want to or not, I can only paint what I see as I see it, and I have learned that if you just keep doing that long enough, the world will embrace your uniqueness.

It's not enough just to be different. In order to be a successful artist, you need discipline as well as self-expression. The paintings of van Gogh that are most valued are his wildly expressive canvases — landscapes, florals and figures where each stroke of color reaches off the painting to pull the viewer in. Van Gogh didn't start out painting this

way. His early paintings were not so different from the other Impressionists. He spent many years painting, painting, painting everything he saw. His concern was to capture scenes as he saw them. Then, as his vision of the world became more intense in his later years, he had the mastery of technique to make his own perceptions visible to others.

Take chances with pastel

I believe that every artist has a vision, something unique and wonderful to express. Unfortunately, it's not always easy to discover your own personal vision. You can't go hunting for it like a pair of missing shoes. You can't plan it or organize it. You can't take it from a book or another artist. It simply appears. It begins when you make your first strokes as an artist and it gets clearer and clearer the more you create. This book is designed to help you get to that personal expression more quickly.

Pastel is such a great medium for bringing yourself forward. It's quick and direct; it gives you pure, powerful color; and it doesn't get in

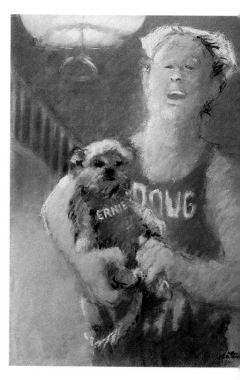

Presenting the world on your terms

The greatest reward for painting is capturing your own world as only you can see it. I have many slightly goofy friends. They all make it into my paintings sooner or later, as in "Doug & Ernie" (25 x 19" or 64 x 48cm). These are the people who make my life rich and their images are what make my paintings memorable. The great challenge for every artist is to capture your own world as only you see it.

your way. I have nightmares about my oil paintings. I literally wake up in the middle of the night worrying whether the bottom strokes were too thick and the top strokes too thin. Did I let the paint dry long enough? Did I use too much medium? By comparison, pastel is so easy. You put it down. If it looks good, it's right. That's it. Yes, there are a few things that are helpful to know about pastels and papers and fixatives, but that is only to make things easier. You don't need a degree in chemistry to be sure your paintings are going to last.

People will tell you there are rules about pastel technique. They say you can't use dark over light. They say you can't use hard over soft. It's not true. I haven't heard one rule about pastel that I haven't seen successfully broken. Pastel is the perfect medium for experimenting, for taking chances, for being outrageous.

What about subject matter? Is there anything that cannot be painted in pastel? No. I've seen tight, classical work. I've seen loose, expressive work. I've seen photorealism and pure abstraction — all expressed brilliantly in pastel. The only limits on pastel painting are the limits you carry within yourself, sometimes without even knowing they are there.

If you are willing to be honest and courageous, this book will help you find what it is you want to express and your own style of expressing it. In fact, if you sincerely want to express your own vision in pastel, this book will tell you everything you need to know.

Enjoy!

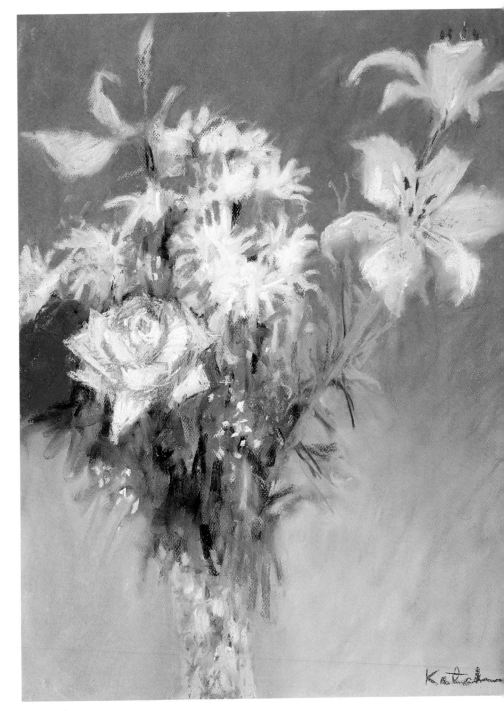

Painting the familiar in a new way
Some people say that every painting has already been done. That would be like saying every flower has already bloomed! Look at the flowers in "Rose & Her Handmaidens" (25 x 19" or 64 x 48cm). Each blossom is unique, unlike any that has lived before it. If we observe the world around us and we are true to our own vision, then there is no end to the possibilities of fresh and different paintings.

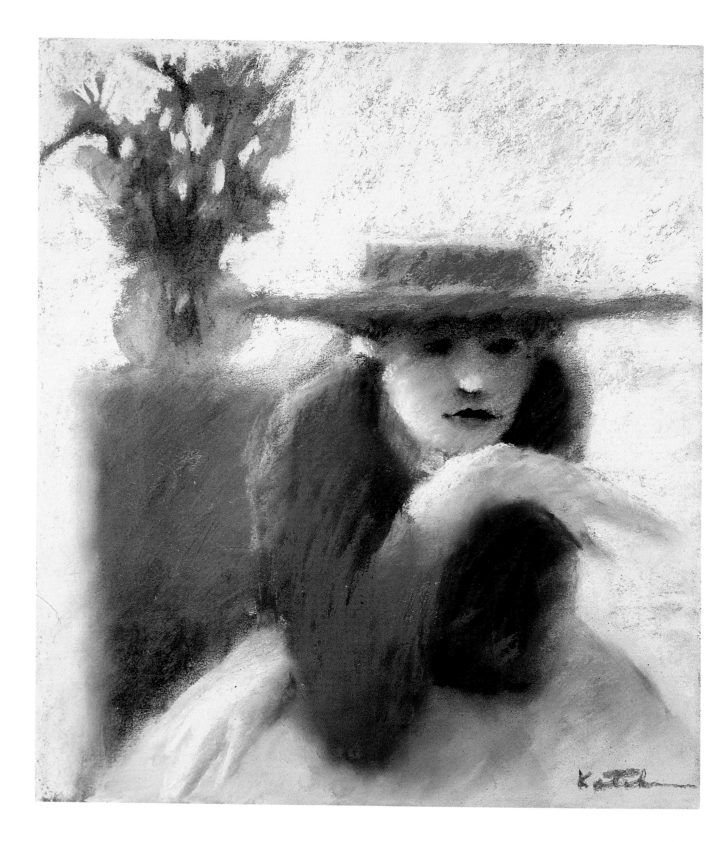

GET TO KNOW YOUR PASTEL STICKS SO YOU CAN
CHOOSE THE RIGHT TOOLS AND TECHNIQUES
FOR THE EFFECTS YOU WANT.

What you need to know about choosing pastels

Walk into any art-supply retailer, and you'll find an abundance of pastel and pastel-painting supplies. It can be overwhelming if you don't know what you need or what you're looking for. To make your choices easier, it helps to understand a bit about the history of pastels and how they're made.

Know the history of pastel

Pastels have a long and interesting history. At the time of Leonardo da Vinci, artists had already been drawing for years with hard sticks of chalk — black, red and white — but the drawings were monochromatic and unexciting to the eye. Artists longed for a simple way of drawing that used more color. In the year 1499, a French artist traveled to Milan taking with him brightly colored sticks of dried pigment, that we now call pastels.

In that same year, Leonardo created his portrait of the Duchess of Mantua, one of the oldest works in pastel that exist today. Drawn primarily in black and red chalk, it also has passages of yellow and brown pastel. The new technique, which Leonardo called "the dry coloring method", took the bright colors of natural pigments used in paints and formed them into dry sticks. The artist was able to add color to a work simply by drawing or rubbing the powdered pigment into the paper.

Pastels were used by a large number of artists during the 16th and 17th centuries. Then, as now, pastels were appreciated because they were quick and simple with no ensuing changes of the brilliant colors due to drying oil or other additives.

The heyday of pastels came in 18th-century Europe where they were used for royal portraits. In 1720, a Venetian pastelist named Rosalba Carriera was invited to Paris by a French art collector. During her year in the French capital, she completed some 50 portraits. These were so well received that she was invited to join the Paris Academy — one of the few women to receive the honor.

Pastel portraits became the rage among the doyens of "society". Of the many French artists who worked with the medium, the most successful was Maurice Quentin de La Tour. De La Tour created grand portraits of his royal subjects. He painted not only the person, but also all the opulence of costume and décor that typified royalty in 18th-century France. Unfortunately, when the monarchy was overturned near the end of the century, this type of painting also went out of fashion.

Late in that same century, the elderly artist Chardin created a new look for pastels. Unlike the soft, delicately blended style of other pastel painters, Chardin painted boldly with individual strokes of color.

About a century later, this expressive use of pastel became commonplace among the French Impressionists. By the middle of the 1800s, Jean-Francois Millet was using hatched or separated lines of

Borrowing from Degas
Degas used to apply pastels over monoprints. I used this technique for ". . . A Pin Drop" (16 x 15" or 41 x 39cm). It's a great way to refine or "punch up" a monoprint that doesn't quite work as is. I let the monoprint dry, then used that image as an underpainting. Even though I covered the entire surface with pastel, the previous color strengthened the finished image.

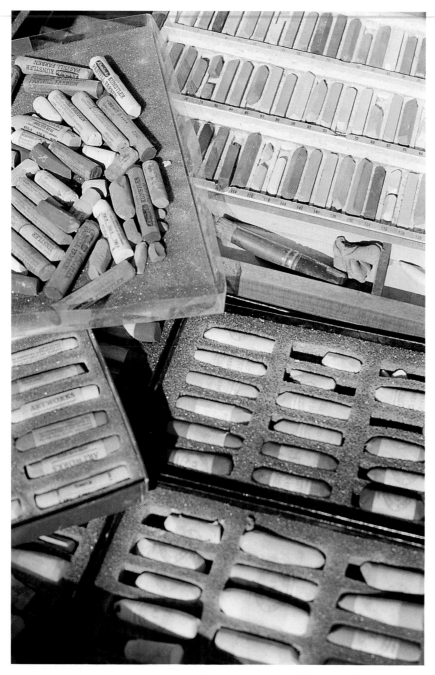

Collecting your materials
Today you have an amazing assortment of pastels to choose from. They vary not only in color and value, but also in the degree of softness and hardness of each stick.

Don't rush right out and buy a giant set of pastels. Take the time to experiment with a variety of brands. Test the softness. Try different colors. Find what best expresses your preferences before you make such a large commitment to one type of pastel.

color to create his rural scenes of peasants in the fields. Edgar Degas, Mary Cassatt and Henri de Toulouse-Lautrec painted urban scenes, combining sharp lines with flat areas of smooth color. Edouard Manet gave pastel a new looseness, suggesting rather than actually rendering facial features. And long before the fast-action camera, Eugene Boudin was able to take pastels to the seashore and capture fleeting moments of light and atmosphere. The Impressionists loved pastel for the brilliance of color and the quick application.

Of all the Impressionists, Degas was the most experimental with pastel, combining it with oil, gouache or monoprint, using pastel pigment wet and dry, even steaming sections of the painting to create special textures.

French artists continued their love affair with pastels into the 20th century. The Moderns, such as Pablo Picasso, Odilon Redon and Édouard Vuillard used pastels early in the century to show their own unique vision. Then another war, this time World War I, brought a decline in the use of pastel.

Since the end of World War II, however, pastels have experienced a growing popularity, especially in the United States. As always, artists appreciate the ease and versatility of the medium. History has proven its permanence so collectors, too, are valuing the colorful images. Pastels by French Masters are selling at auction for millions of dollars. The future for pastel seems to have no limits.

An excellent history of pastels complete with great illustrations is *Pastels From the 16th to the 20th Century* by Genevieve Monnier published in paperback by Bookking International.

Learn how pastels are made
The word pastel comes from the Italian "pasta" or paste. From the beginning, dry pigments were ground into a powder. Then they were mixed with water to form a paste. This dough-like mixture was rolled or squeezed into sticks and left to dry. Over the years, a variety of additives were tried to make the sticks

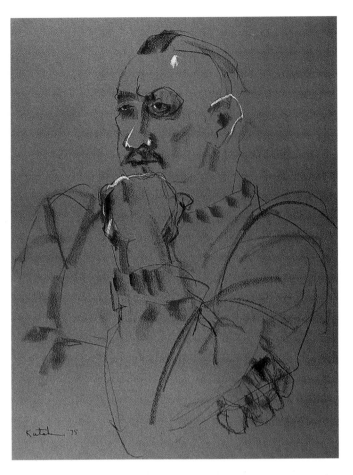

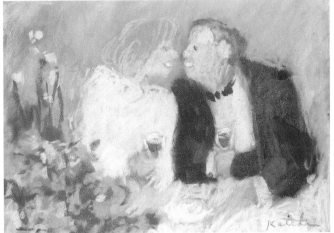

Expressing through strokes
With pastel, the lines themselves can contribute to the expressiveness of a drawing or painting. Look at the calligraphic quality of the lines and strokes in "The Colonel" (25 x 19" or 64 x 49cm). They vary from thick to thin, light to dark, curved to straight. Because there is no pen or brush to refill, lines can be drawn in an unbroken rhythm.

of color more or less hard.

Imagine rubbing a piece of the beautiful blue stone lapis lazuli across a sheet of paper. It might scratch the surface, but it will leave no other mark behind. But grind that blue stone into a powder, and then it can be rubbed into the fibers of the paper to create a blue mark. Unfortunately, in powdered form, the color is difficult to control. The challenge was to make a painting material soft enough so that it would easily rub onto the surface, but still hard enough for the artist to hold in the hand.

In 1583, an artist in Cologne wrote, "Painters fashion these coloured crayons in the form of a cylinder and roll them with a mixture of fish glue, gum arabic, fig juice or, what I think is better, whey". A Parisian artist in 1687 suggested making a paste from white clay and water, then adding powdered color and a small amount of honey and gum arabic. In the 18th century, artists combined powdered color with milk, stale beer or oatmeal water.

The sticks of color were made by each artist or by assistants in the artist's studio. The variety of colors was limited to the mineral or organic pigments readily available to the artist. Quantities were limited, and the rare pigments were quite expensive.

By the 18th century, however, European traders were traveling throughout the world and among the goods they brought back were wonderful new pigments from such exotic places as Egypt, Cyprus and Iran. At the same time, the evolution of chemistry made it easier to produce and manipulate pigments in the laboratory so the artist's palette of pastels expanded dramatically. By the end of the 19th century, artists were able to purchase pastels from factories. A catalogue from the Sennelier company shows that in 1896 more than 700 colors were available to artists.

Today there are numerous makers of pastels in several countries. The brands differ in hardness, color, density and quality of pigment, but most of them are

Incorporating variety in your strokes
This quick color study called "A Toast to Us" (6 x 8" or 15 x 20cm) shows how easily a full composition can be developed with pastel. Flat, smooth strokes move the background behind the figures, while small, unblended strokes suggest details of flowers and facial expression.

still made in the traditional way. Powdered pigment is mixed with water and a small amount of glue, usually gum tragacanth. Pure colors are made lighter by adding white chalk called calcium carbonate. In larger factories, the combination is blended in machines that look like bakery mixers. The finished paste is squeezed into long sticks that are cut, dried and labeled. Some manufacturers roll each stick by hand. Today it is also possible to buy the wet pastel mixture so that artists can mix their own colors and roll sticks of any size.

Understand the meaning of "soft" pastels

Even though most pastels are called "soft pastels", a few are considerably softer than others. Some colors glide onto the surface with hardly any pressure, while others need so much pressure to make a mark that they actually scratch the surface of the paper. The relative hardness or softness of the sticks of pastel will have a greater impact on your work than any other element.

What makes pastels hard or soft is 1) the amount of glue mixed with the pigment and 2) the nature of the pigment. Some manufacturers use more glue to keep the sticks from crumbling; the more glue, the harder the stick. Also some colored minerals are naturally very hard and they produce harder pastels. Dark pigments have traditionally produced hard sticks of pastel, but several manufacturers are now providing assortments of dark colors that are quite soft.

Some of the pastels that are called hard pastels are not pastels in the true sense.

Hatching a plan
"Rose" (19 x 25" or 49 x 64cm) makes use of visual blending to convey the image. Notice the repeated directional strokes of color that blend together from a distance. This type of stroke is called "hatching". Using harder pastels helps to keep the strokes separate.

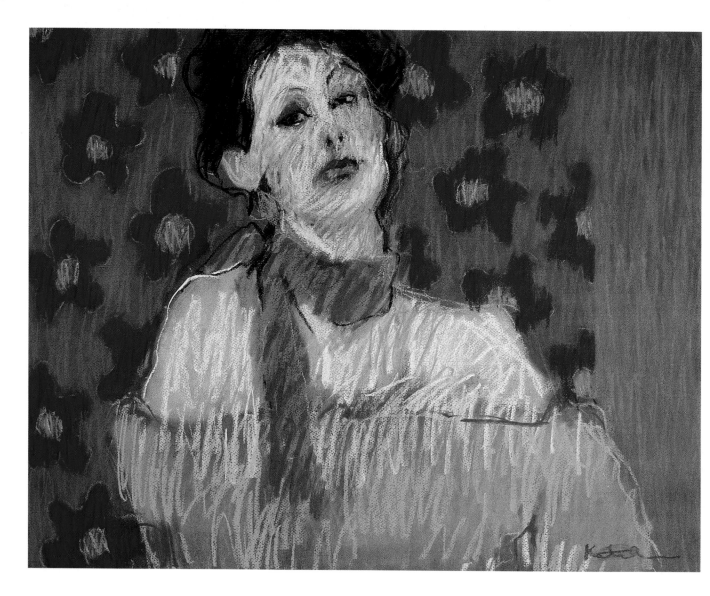

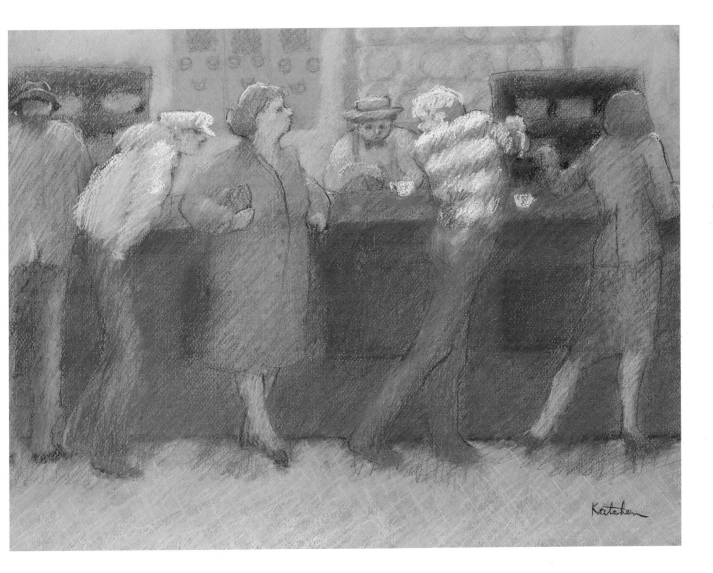

They are actually sticks of chalk that have been colored with liquid dyes. They are hard because they are sticks of compressed calcium carbonate. They can be used for many of the techniques of pastel painting, but because they are made with dyes rather than powdered pigment, some of them fade quickly in sunlight. It is especially important to test them for color fastness. (For instructions, refer to the box on testing for color permanence on page 21.)

I like to think of soft pastels being arranged on a scale of softness. Some of the harder brands are Holbein, Daler-Rowney, Faber Castell, Winsor & Newton and Rembrandt. Somewhat softer are Art Spectrum, then Unison, Sennelier and Wallis. Some of the softest are Schmincke, Great American Artworks and Diane Townsend. Within each of these brands, some sticks are harder or softer

depending on the pigments used. When I buy individual sticks of color, I make a small mark with each one to test for softness.

I encourage artists to try as many brands as possible. Each type of pastel produces different effects, and the only way to know which is most expressive of you is to try them all. Many brands are available for purchase by the stick, which makes it easier to experiment. I love going into a large art-supply store and picking out new colors to try. Many brands also have small introductory sets of colors. Try a few sticks of several brands before you invest in a large set of colors.

In order to become freer in expressing yourself, it helps to know which kind of pastel will most easily produce the desired result.

Defining with line
Harder pastels are excellent for fine rendering. In this scene of one of my favorite coffee bars, which I call "Double Decaf Low Fat Latte" (18 x 24" or 46 x 61cm), I was especially interested in the shapes and gestures of the various figures. The thin contour lines around and within the figures help to define them. To draw fine lines, you can use a pointed corner of a square pastel stick or you can sharpen a pastel stick to a point using a knife or sandpaper.

17

REALLY KNOW YOUR PASTELS

Learn to determine how relatively soft or hard your pastel sticks are, then you will be able to choose the right one for the job.

Pastels are made by mixing dry colors, a small amount of glue and enough water to turn the mixture into a paste. The mixture is rolled or pressed into sticks and left to dry. Although most pastels are called soft pastels, they vary widely in the actual softness. The amount of glue and the hardness of the pigment, often a ground mineral, will determine how hard or soft each dried stick is. The relative softness or hardness of a stick of pastel will have a tremendous impact on your application of color, as shown in the following illustrations.

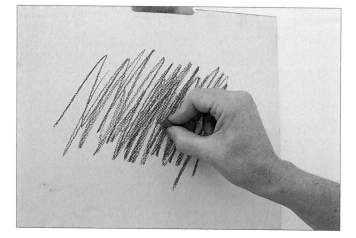
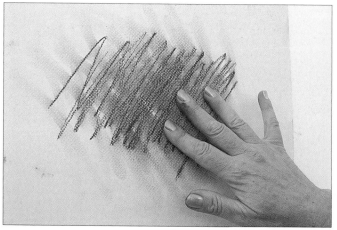

Using hard sticks
Here I am using a fairly hard stick of Holbein pastel. The harder pastel makes thin, definite strokes that stay on the surface of the paper. Even when I blend the pastel strokes with my fingertips, the original strokes remain visible. Most of the pigment remains in the lines, with a small amount of loose pigment spread thinly over the surface.

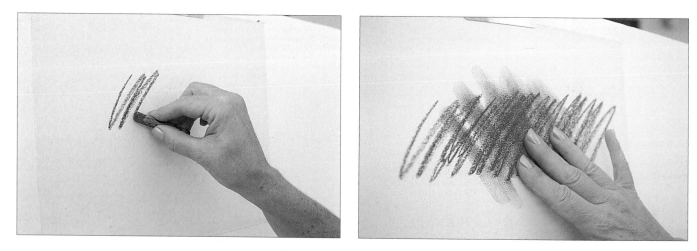

Using medium-soft sticks
A medium-soft stick of Sennelier pastel makes a denser line. The most obvious difference appears in blending, where the original strokes begin to disappear.

Here are some of the effects you can expect from harder and softer sticks of pastel.

HARDER PASTELS ARE ESPECIALLY GOOD FOR:

1. Fine lines, edges and details. To get a very fine point, you can sharpen the edge of the pastel stick with sandpaper or a sharp knife. Because the stick is hard, it will hold the point for some time.

2. Definite placement of color. Harder pastels take more pressure to make a mark. That pressure pushes the pigment into the surface of your paper, locking it into the fibers. This means the strokes of color will stay where you put them. As a result, it is excellent for careful rendering and modeling.

3. Building up images slowly. Because each stroke takes a significant amount of pressure, the color goes on slowly. Thus you have more time to develop your image.

4. Layering strokes of color. By layering strokes of color, you can build up deliberate subtleties of color and value. You can hatch, cross-hatch, scribble or stipple marks of related or contrasting colors. As you increase the number of these strokes, they will begin to blend visually, that is, appear as solid color to the eye. For example, strokes of primary colors put together will appear to be a secondary color. Strokes of complementary colors, such as blue and orange, will appear gray.

5. Allowing the paper color or background color to remain part of your painting. Unless you use excessive pressure, strokes of harder pastels will sit on the surface of your textured paper, creating an effect like scumbling in oil painting. That's because the textured paper has a surface of peaks and valleys. The hard pastel will cover the peaks, leaving the valleys to show through with their original color. This can be particularly effective with black paper.

SOFTER PASTELS ARE ESPECIALLY GOOD FOR:

1. Blending. Softer pastels allow you to blend well because the pigment moves easily on the surface of your paper. With your fingertips, you can spread color from one section to another, creating a smooth gradation of color. With your whole hand or a paper towel, you can wipe pigment across the entire surface, creating a smooth layer of color like a watercolor wash. It is also easy to create new colors by laying down individual strokes of different colors and then blending them together into one solid tone.

2. Strong color. Very soft pastels take little pressure to make a mark. With only moderate pressure, you get immediate marks of strong color. Because it's easier to press the color into the fibers of the paper, you can quickly eliminate all trace of the paper underneath, leaving only the color of the pastel pigment.

3. Covering large areas quickly. You can cover large areas quickly and powerfully with a few strokes of the side of a stick. Some manufacturers also make over-sized sticks of pastel that are ideal for producing large strokes.

4. Expressive gestures. With as little as one stroke, you can get solid color that makes a powerful statement. By varying the pressure of that stroke, you can achieve a full range of values for that color. A soft touch will give you the lightest value, while a heavy stroke will give you the darkest. Within the same stroke, you can also go from the thickness of the flat end of the stick to the thinness of a corner, capturing all manner of moods and gestures with individual marks.

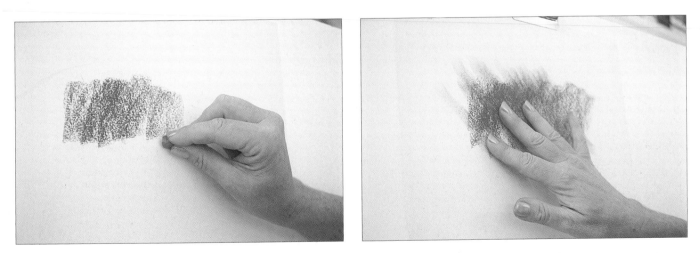

Using very soft sticks
With a very soft stick of Schmincke pastel, the individual strokes are barely distinguishable from one another. When I blend these strokes, they make a nearly solid layer of smooth color.

Celebrating with color

"Honkeytonk Heaven" is a glorious celebration of color. As in the best of impressionist painting, each stroke of color has a presence of its own, made possible by the use of very soft pastels. Now look closely at the detail of his hat which was, in fact, a buff color. I painted it with heavy strokes of ochre, green, blue, purple, orange and red. This rich use of color gives the hat three-dimensional form. It conveys the dramatic light inside the saloon and provides a vital painting surface texture.

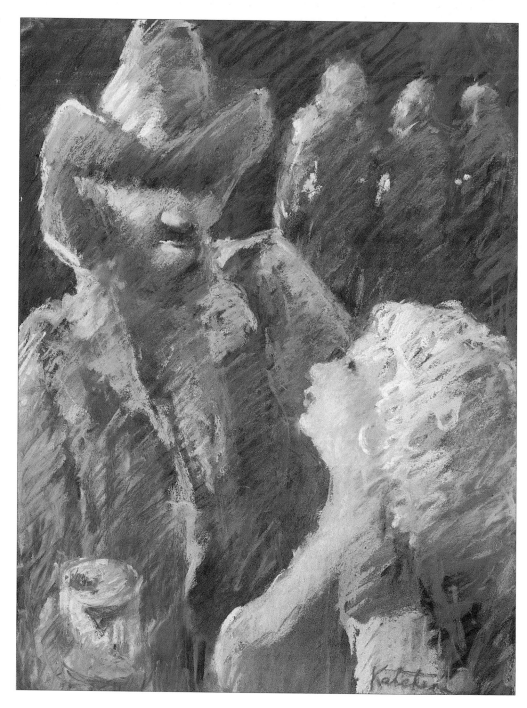

HOW PERMANENT ARE YOUR COLORS? - A SIMPLE HOME TEST

Some people think that pastels are less permanent than oil paints. This is not true. Most high quality pastels are made from permanent pigments that will not be altered by either light or heat. However, there are some pastel ranges that contain "fugitive colors", colors that will fade. Exposure to light and/or heat can also cause some of them to fade, even under glass. Using these impermanent pastels will cause your paintings to change over time as those particular colors become lighter.

Eventually the fugitive colors will disappear altogether.

There is a simple test you can do at home or in your studio to determine the permanence of particular colors of pastels. On a sheet of paper, draw lines of the colors you want to test. Then cover half of the paper by taping to it a smaller sheet of heavy paper or board so that half of each colored line is visible. Tape the full sheet to the inside of a window that receives an ample amount of sunlight. The test

side should face the sunlight. Keep a record of which pastel colors you used.

After a few weeks, remove the test panel and compare the exposed half to the hidden half. If a color on the exposed side is lighter (faded), you know that stick of pastel is not color-fast. Reassemble the test and return it to the window. Continue to monitor the test for several more weeks.

This test can also be used for the color-fastness of paper.

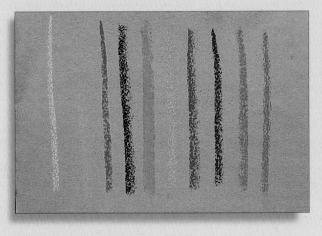

Draw lines of several sticks of color onto a sheet of paper.

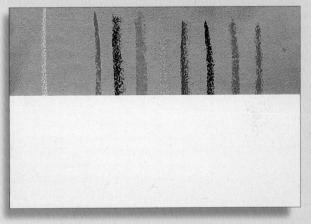

Tape a sheet of mat board onto the paper, covering half of each stroke. Set the paper in a window for several weeks to test for color-fastness.

Determine which colors you need

I have known artists who began their pastel experience by buying a full set of 500 to 1,000 sticks of pastel. That is not necessary, and in some cases I think it is detrimental. When you are faced with such a large array of colors, the natural tendency is to try to use them all at once. The result, for all but the most accomplished artists, is absolute chaos. I have seen it over and over again in workshops. Faced with choosing from such a bountiful palette, artists tend to forget everything else. Shape, value, gesture, even color harmony are ignored in the quest to find the perfect color for each individual stroke.

In my pastel courses, I limit students to just three sticks of color. They can select any three colors, but they must include a light, a medium and a dark value. The students complete an entire painting with only these three colors, and in the course of the exercise, they learn a great deal about mixing and blending pastels as well as capturing value.

I recommend that pastel beginners start out with no more than 20 to 50 sticks of color. Include all the primary colors (red, yellow and blue), the secondary colors (orange, green and purple) and perhaps a few browns. Make sure you have

a full range of values — lights, mediums and darks. I avoid pure white and pure black because they tend to deaden the other colors.

As I suggested earlier, either pick individual sticks of different brands or buy a small starter set of one or more types. Pastel provides unlimited possibilities for mixing and blending colors within a painting, a wonderful way of expressing your own individuality. However, if you start out with a massive set of colors, the colors themselves will dictate how you paint. Ironically, your personal expression will be stifled by the abundance of colors.

HOW TO BUILD UP COLOR WITH HARD PASTELS

Unless you use excessive pressure with harder pastels, each stroke leaves only a small amount of pigment behind. So with this kind of pastel painting, I build up images with many layers of strokes. The materials themselves — fairly hard Holbein pastels on black Hahnemuhle paper — put a stop to my usual break-neck speed. I must work slowly and deliberately, which gives me the opportunity to develop greater subtleties of color and value.

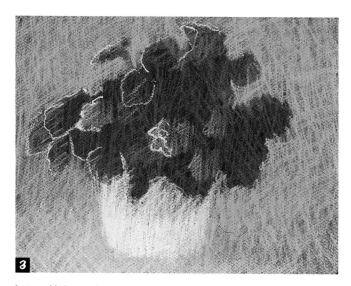

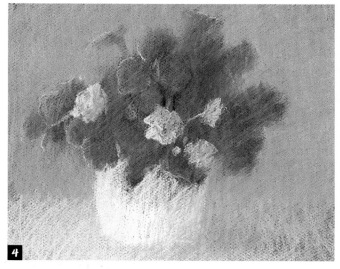

Establishing shapes

I began with a simple drawing to establish the large shapes, choosing my pastels for value as well as color. With vertical strokes, I hatched in colors for each of the large shapes. The light pot was done with a very light yellow since I rarely use pure white. The actual colors were not as brilliant as they appear — the black paper makes every color seem more intense.

Layering for volume

I made the colors more solid by adding layers of diagonally hatched strokes. The light was falling on my subject from the left, so I began to add bright highlights of light ochre on the left and darker purple shadows on the right.

Intensifying color

I continued intensifying the color and value by layering strokes. Notice that I carried some of the ochre from the table top into the background to add color harmony. I began to show spatial depth by moving from lighter ochre at the front of the table to darker, duller ochre at the back of the table. I deepened the shadow area and used light outlines to explicate the highlights.

Enhancing the light source

To solidify my colors, I continued adding more and more layers of colored strokes. Aware of my light source, I applied lighter and warmer greens to show where light was falling on the leaves of the plant. Even within each blossom, I revealed the direction of light fall.

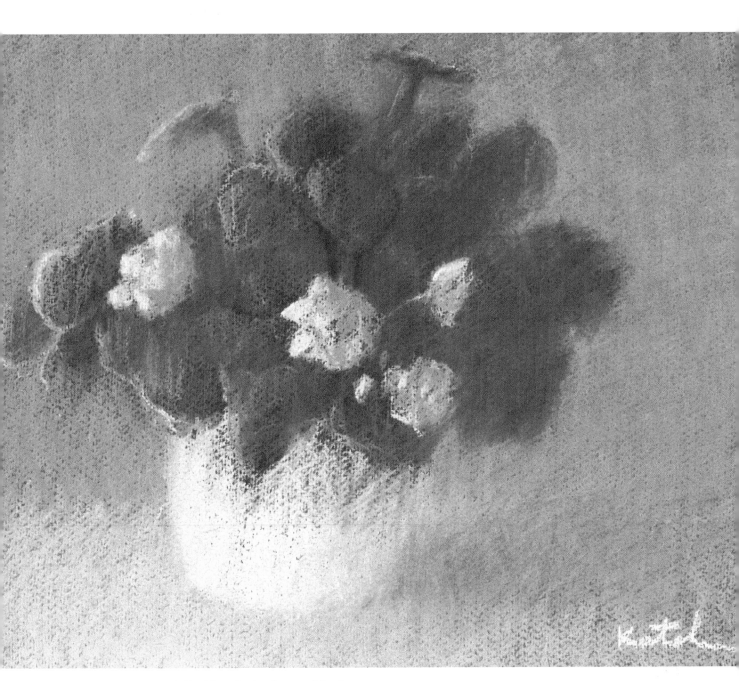

Pushing the background back
To finish "A Touch of Violet" (11 x 14" or 28 x 36cm), I adjusted
the background, moving it back in space by graying out the
colors. Notice how the strokes of dull green provided a spark of
contrast to the red-orange. I fully developed my cast shadows.
Only at the end did I add small details, such as the yellow spots
in the flowers.

HOW TO ADD VIBRANT COLOR WITH SOFTEST PASTELS

This painting shows the amazing intensity of color possible with soft pastels. All the pigment is applied with direct strokes — no blending! Notice that very smooth areas of color are possible with soft pastels even without blending with fingers or cloth. I am working on black Hahnemuhle paper with very soft Schmincke and Great American pastels.

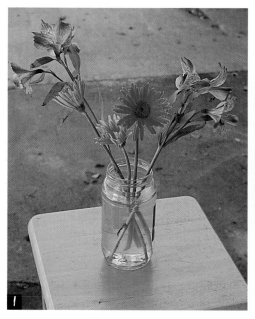

Working with a "live" model
With florals, I like to work directly from live flowers rather than from photos. This gives me a greater intimacy with the flowers. It also adds the pressure of working quickly to capture the blossoms before they open further, turn to the sun or wilt.

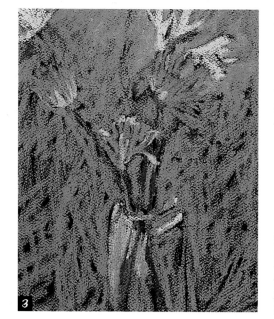

Refining the underpainting
I loosely blocked in the main shapes. I tried a pink in the background, but I didn't like the way it worked with the orange, so I painted over it with green ochre. You can see how dense the color became in the upper right with just two layers of strokes. One of the advantages of very soft pastels is that you can easily cover up previous colors simply by painting over them.

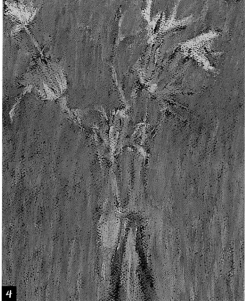

Experimenting in the background
I still didn't like the background color, so I tried blue, using strokes of several different blues for greater color richness. Because blue is the complement of orange, it made the daisies appear more brilliant. I also began to develop color in the vase.

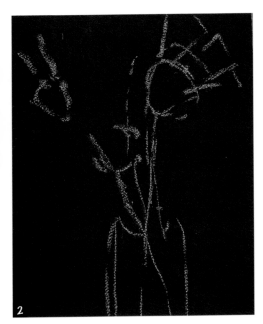

Sketching the shapes

The first step was sketching the basic composition. I used light strokes of an orange pastel. Even a medium value will show up brightly on black paper. My concern was not to develop the entire subject here, but simply to indicate the placement and thrust of the composition.

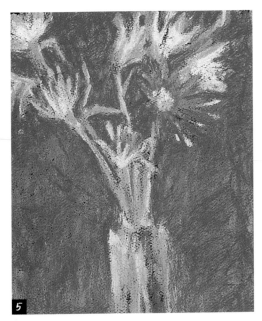

Adding color to the subject

Next, I began to refine the shapes and colors of the flowers, carrying the colors of the stems down into the vase to give a more solid foundation. I intensified the background with more strokes of deep blue and violet.

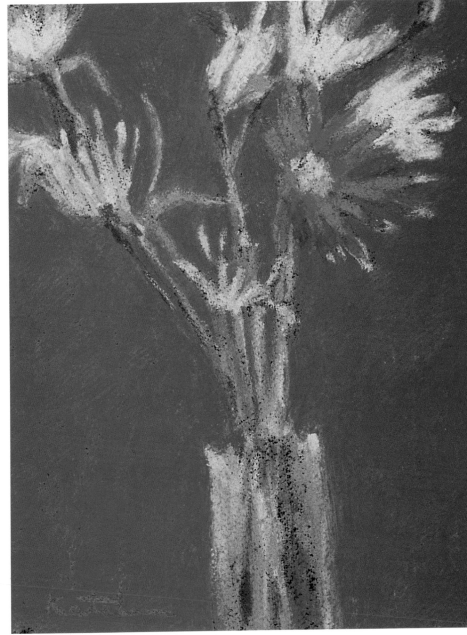

Harmonizing with color

I completed the painting by intensifying all of the colors, especially the background. I had to use a lot of pressure to get the color to adhere over the previous layers. As a result, the background color developed a very smooth surface. I refined the contours of the subject by carefully defining the negative space, the area around the flowers. I added a final accent of red to the vase to enliven the lower part of "A Toast to Hue" (14 x 11" or 36 x 28cm).

HOW TO BLEND SOFT PASTELS FOR GENTLE, SUBTLE EFFECTS

Here again I was working with very soft pastels on black Hahnemuhle paper, but this time I wanted to show the techniques and effects of blending. The pigment from very soft pastel strokes sits lightly on the surface of the paper, making it possible to move it around. As a result, it is easy to achieve soft, atmospheric images.

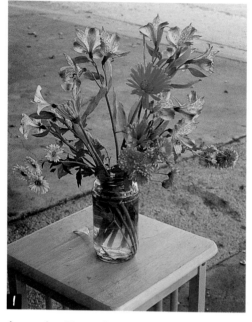

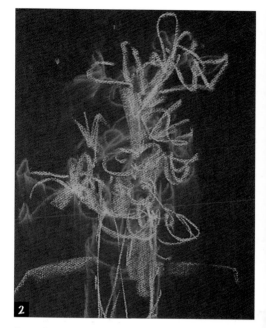

Arranging the optimum set-up

I believe the most crucial aspect of painting a floral is arranging the flowers. In "A Toast to Hue", I used just a few stems and spread them out, allowing the shapes of negative space within the arrangement to become a major part of the composition. Here, I added more flowers and arranged them closer together to create a denser subject. As I painted, I rearranged and eliminated blossoms within the painting in order to create the strongest design.

Drawing the subject

I began with a simple drawing of the subject. I used green, the natural color of the foliage.

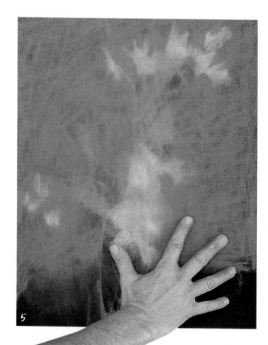

Overlapping color

With purple, I blocked in the background. I deliberately used very few colors. As I wiped them back and forth over each other, they automatically blended to create a wider range of hues. I used the background to show the large shape of all the flowers together. Next, I blended the color with my fingertips, which removed less pigment than using a paper towel.

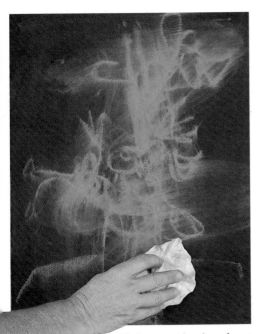

Wiping out the drawing

I wiped out the image with a paper towel, which is a deliberate part of my process. Wiping out allows me to refine the composition. It also gives me a base coat of color on the surface of the paper. This softens the effect of the overpowering black and helps build a background color.

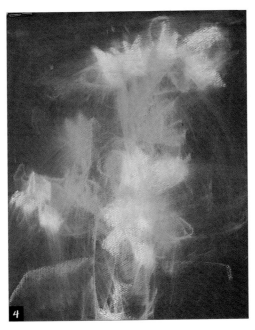

Blocking in with warm colors

I began to block in the main color/value shapes with warm colors. What looks like white is actually a light pink. I used broad strokes of the side of the pastel to keep the shapes vague. At this point in the painting, I avoided specific contours and details. Again I wiped everything out with a paper towel. Each time I blended colors, I stopped and stepped back, looking to see what nuances of color and form had appeared.

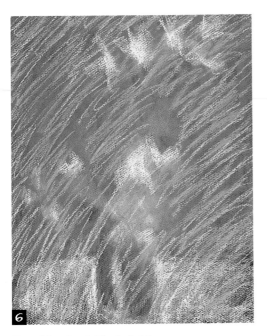

Knocking back the brights

Once I'd filled in all of the shapes and intensified the colors, I felt they were too bright. To tone them down, I hatched over the entire painting with strokes of yellow ochre and mauve.

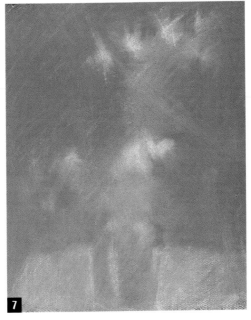

Softening the initial block-in

Wiping out again with my hand, I made the color softer, warmer and more atmospheric.

27

Restoring some tooth with workable fixative

I redefined all of my colors and color shapes — pink and orange in the flowers, greens for the foliage, blue for the background. Then I sprayed the entire surface with workable fixative to restore the tooth of the paper and also darken much of the pigment. Looking at the dark areas within the foliage, I decided they were not quite dark enough. I sprayed them again before going on to the next step.

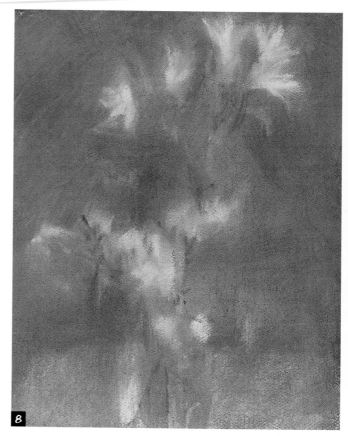

Painting negatively

Using a light lavender pastel, I strengthened the negative spaces outside of and within the bouquet. I blended all of this light color using a paper towel over my index finger. I kept the pressure light so as not to remove too much pigment. The light background now creates a wonderful, dramatic value contrast against the dark values of the flowers.

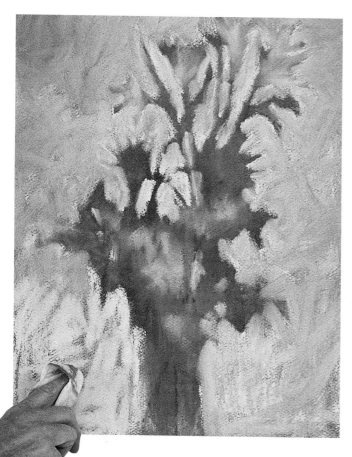

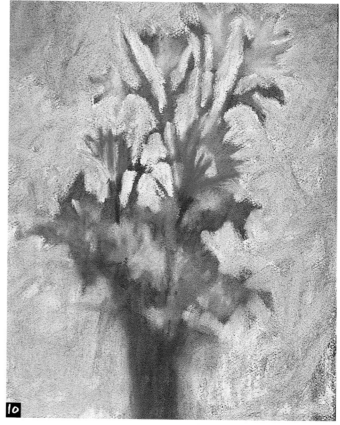

Making the colors pop

With the composition established, I went back into the flowers with intense colors — strong orange, yellow and pink. Again, I sprayed on fixative to keep these colors in place.

28

Blending with light strokes

To finish "Daisies in the Mist" (18 x 14" or 46 x 36cm), I lightly hatched over the background with a light pink. Then I carefully blended the entire painting. I used a paper towel wadded up into a ball so there were no loose edges to drag through the pigment. I used a circular motion and covered the entire surface with very light pressure. This softened and blended all of the edges without removing much pigment. With light strokes of pastel, I enriched a few areas in the flowers to give added punch to the image. Through repeated blending, I eliminated all of the individual strokes. Up close you see blurred sections of color, but from a distance you see a softly atmospheric image of the flowers.

Mixing pastels with other media

Because pastels don't require any solvents, they can be combined with many different media. In "Jazz for the President" (19 x 24" or 49 x 61cm), a demonstration started when President Bill Clinton visited a local art center, I used acrylic for the large geometric shapes. I layered on pastel for details and surface texture. Eventually, the painting became part of the president's personal collection.

Trying a new surface

"Liver And Onions" (9 x 12" or 23 x 31cm) was first painted with watercolor on a fairly rough watercolor paper. After the painting had dried, I refined and enhanced the original image with pastel. The roughness of the watercolor paper gives an interesting texture to the pastel strokes.

Enjoying the ease of pastel

Historically pastel has been prized because of its ease of application — you simply stroke the color onto your surface. There are no solvents so there is no waiting for it to dry and no change of color as it dries. Notice how few strokes of color it took to make "Tsigane" (12 x 9" or 31 x 23cm).

REFRESHER COURSE
MAIN LEARNING POINTS IN THIS CHAPTER

1. Pastels have been used by artists for more than 500 years. There are pastel paintings that look fresh and vibrant after hundreds of years.

2. Pastels are basically sticks of pure color. Ground pigment is held together with a small amount of glue. Depending on the amount of glue and the type of pigment, some soft pastels are softer than others.

3. Harder pastels are best for:
- Fine lines, edges and details.
- Definite placement of color.
- Building up images slowly.
- Layering strokes of color.
- Allowing background color to show through.

4. Softer pastels are best for:
- Blending.
- Strong color.
- Covering large areas quickly.
- Expressive gestures.

5. It is wise to sample many brands and colors before you buy a large set of pastels.

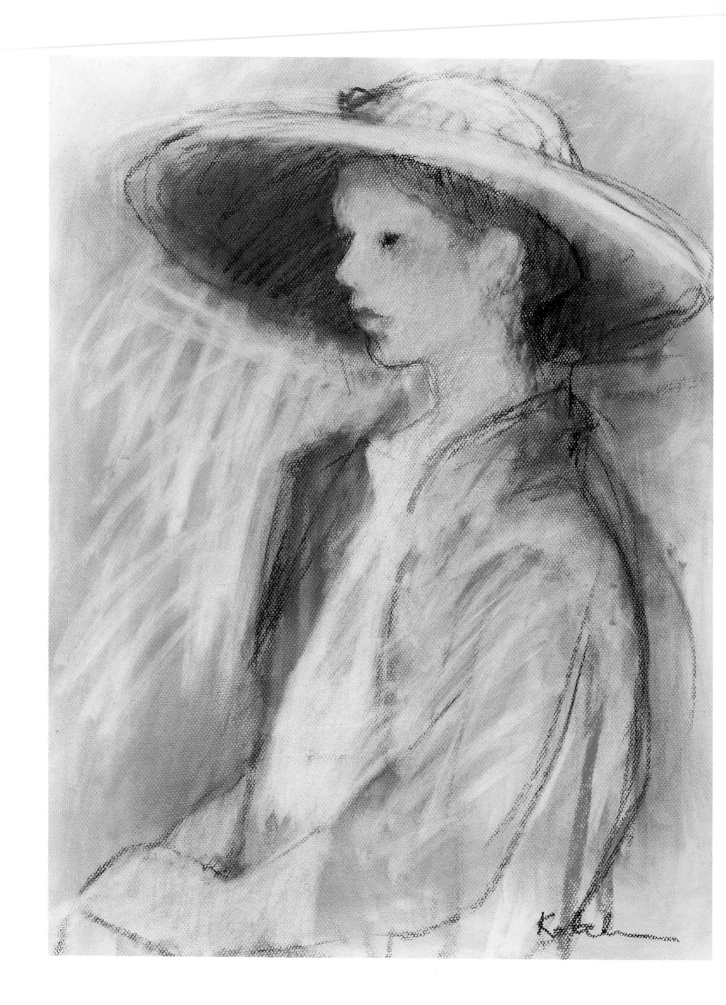

32

EXPERIMENTING WITH A VARIETY OF SURFACES CAN YIELD
A WIDER ARRAY OF PERSONAL, EXPRESSIVE RESULTS.

What you need to know about paper

After the pastels you choose, the most important decision you make will be what paper to use. There are a vast number of papers and pastel boards available. Again I suggest you try a wide variety in order to know which ones best express your own style. The main variables to be considered are color, texture and weight.

Pick a paper with color

The color of your paper will begin to set the tone of your painting before you even make a stroke. In addition, it will effect the appearance of every colored stroke you place on top of it.

The hardest paper color to use with pastel is white. Every stroke of color you place on white paper will look garishly bright until most of the paper is hidden, making it difficult to judge color brilliance and value. What might be even worse is that any little bit of white paper that shows through your finished painting will make the color look skimpy and incomplete.

Fortunately, there are a variety of techniques for toning or coloring white paper. I often start my painting with a few gestural strokes of very soft pastel to locate the main shapes. Then I wipe that sketch with a paper towel, rubbing pigment across the entire surface of the paper.

If you are working on a heavy white paper or board that will tolerate moisture, such as watercolor paper, you can tone the surface with a thin wash of watercolor or acrylic paint. Let the underpainting dry before proceeding with pastel. Some artists tone their white paper with the complement or opposite color from what they will be later painting in pastel. For instance, under a section that will be blue sky, they might paint orange. After the painting is finished, tiny bits of orange may show through the blue of the sky, creating a more vibrant color surface.

The most difficult colors of paper, after white, are very brilliant hues, such as intense yellow, orange, red, turquoise, etc. The strokes of color you place on top of these brilliant papers will seem to vibrate, again making it hard to judge intensity and value of your pastel strokes.

Black also makes all of your pastel strokes seem to jump off the page, but handled well, black can add a desirable depth and drama to your finished work. A technique that I have developed with black is to wipe my initial sketch across the surface of the paper. After I have a thin layer of pigment over the entire paper, I use a kneaded eraser to draw through that pigment. The kneaded eraser will pull up pastel pigment, leaving black lines where the paper shows through. Sometimes I use this technique for developing the shadow areas in a painting. You can see this technique used in the painting demonstration "The Blended Egg" on page 60.

Using paper as part of your palette

Sometimes I like to use the paper's color as one of my painting elements. Early in "Victorian Miss" (25 x 19" or 64 x 48cm), I wiped a light layer of ochre pigment over much of the surface. Later I erased through the thin color with a kneaded eraser. In several places, I left the erased lines of light gray Canson paper to provide part of the color and surface texture. In the blouse and along the rim of the hat, I erased nearly all of the pigment, creating my brightest areas with the natural color of the paper.

BY TAKING ADVANTAGE OF THE TEXTURE IN YOUR SURFACE, YOU CAN ADD VIBRATING COLOR TO YOUR PAINTING

I created this painting on gray Colourfix paper from Art Spectrum. The acid-free paper is coated by silk-screening a silica mixture onto it. The result is a paper smooth enough for easy blending, but with enough tooth to hold several layers of strokes in place.

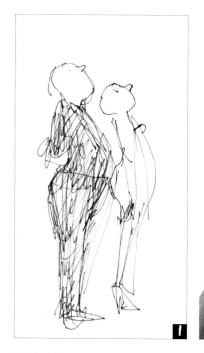

Taking inspiration from gesture

The idea for this painting came from the posture of a man I know who stands with his rear end sticking up in the air. In this loose gesture drawing, I worked out the posture of the man and his partner, both with their noses and their behinds pointed up to the heavens.

Getting the drawing right

I began by blending a first layer of pastel onto the surface. My initial loose sketch of the figures in red violet was too high in the composition, so I wiped them out with a paper towel. I redrew the figures and indicated the crowd in the background with strokes of blue-violet. Then I wiped it all out. Next, I pulled out the lightest shapes in the painting with a kneaded eraser. Unlike most sanded surfaces, this paper allows for easy erasing.

Going for the basics

Next, I blocked in the shapes with just a few colors. I used a pink for the skin and a medium blue and dark purple for clothes. I used a range of green ochres for the background, going from the lightest at the bottom to the deepest at the top to move the background back in space. I left some areas of the previous color untouched. I kept my palette simple for the sake of color harmony, knowing that I would be blending and that the colors I chose would mix together to give a broader range of colors. I didn't bother with details yet — they would only be blended out later.

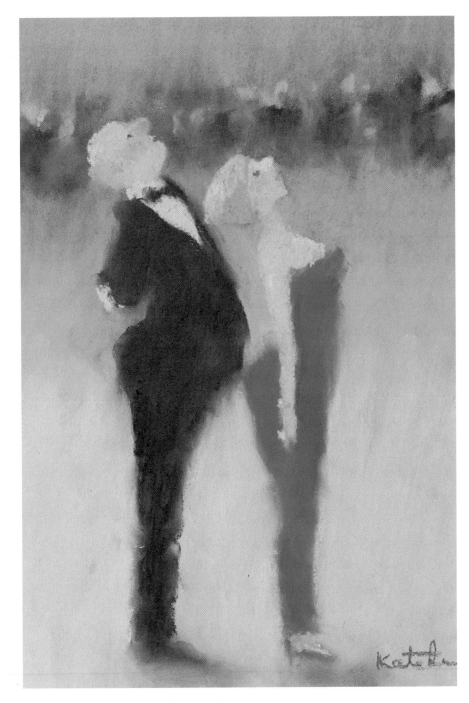

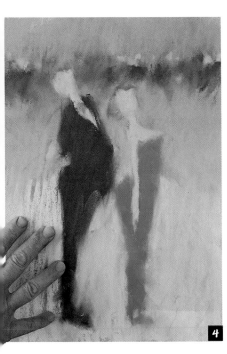

Blending by hand
Using my fingertips, I lightly blended the areas of color into each other. My concerns were to solidify color and blend my edges. Because of the smoothness of this paper, I needed very little pressure to move the pigment.

Savoring vitality
I refined the contours a bit, added a few details and voila! "If Only the Rest of the World Could Be Like Us" (13 x 9" or 33 x 23cm) was done. It would have been possible to keep working on this painting to make it a more refined image, but it already conveyed my original intent. Look at the wonderful vitality of the blended strokes in the background figures. I find it is often more effective to merely suggest form and movement rather than delineate all of the details in a painting.

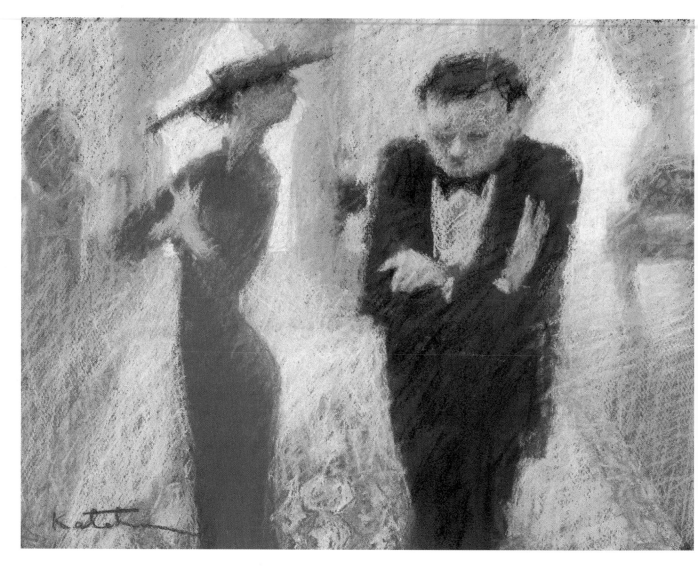

Letting the paper shine through

Working on black Hahnemuhle paper, I created "The Voice of Reason" (17 x 22" or 43 x 56cm) with many, many layers of thin scribbled strokes. The paper has a slightly rough, uneven texture that allows bits of color from previous strokes to show through the top layer.

The texture becomes quite obvious in this close-up view of the man's face.

TiP 2

Sometimes subtle differences in the surface texture of a sheet of paper are not visible to the eye, as in the different sides of a sheet of Canson Mi-Teintes. Like most other pastel papers, Canson has a rougher side and a smoother side. The best way to judge the texture of a surface is by touch — close your eyes and test the surface with your fingertips. With practice, you can feel the difference more easily than you can see it.

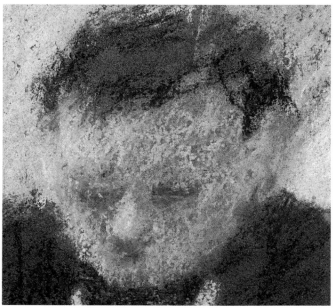

Eliminating white with washes
Working on watercolor paper can be a problem because it is usually white. The pastel pigment stays on the surface allowing bits of white to show through. Those white dots make the color look thin and the painting appear incomplete. You can eliminate the white either with a watercolor or acrylic underpainting, as I did here in "All That Glitters" (17 x 13" or 43 x 33cm), or by wiping your first strokes of pastel into the entire surface. Thanks to the unusual texture, yet solid color underneath, many viewers have been drawn to this painting.

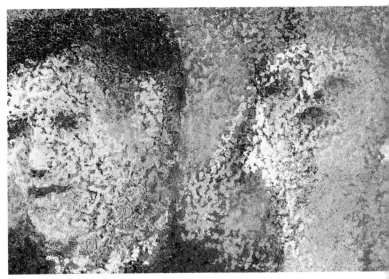

What colors of paper are easiest for the less experienced artist? Any of the middle-value, less intense colors work well. For beginners, I often recommend earth colors, especially medium browns, tans and grays. These provide an unobtrusive tone that blends easily with any added pastel colors.

As you grow in experience and confidence, try some of the more difficult colors. They will set up challenges that force you to be more inventive with your painting.

Experiment with textures

You need texture or "tooth" in a pastel surface because that's what grabs the pastel pigment and holds it in place. If you make strokes of pastel on a very hard, smooth surface, the pastel pigment will slide right off.

There are several papers manufactured with a textured surface that work well for pastel. Perhaps the most commonly used pastel paper is Canson Mi-Teintes. It is a medium-weight paper that comes in a wide variety of colors and has a moderate texture. One side of the paper is a bit more textured than the other, and the rougher side is the one I usually use.

Strathmore, Fabriano and others make pastel papers in a good selection of colors, but they're not quite as heavy as Canson. The heavier paper allows for more working and re-working. Even heavier in weight than Canson are Hahnemuhle and Fabriano Morillo. Since I do a lot of experimenting and changing my mind with pastels, I appreciate a very durable paper.

If you want a smooth look to your finished painting, the texture of the paper can be hidden with a heavy application of pastel or by blending. For most of my paintings, though, I like to leave the texture visible, at least in parts of the painting. The pattern of the texture gives a more interesting surface to the color.

On the other hand, you may want to play up the texture in your surface by using an oil painting technique known as "scumbling". I often push or blend my first strokes of pastel right into the paper's fibers, creating a smooth layer of color. Then I lightly stroke with another color, keeping the pigment on the top of the paper. Light strokes with the unwrapped side of a pastel stick work well for this technique. The earlier color shows through in the recessed spots, revealing the textured surface of the paper. For a good example of scumbling see "All That Glitters" above.

Some other papers that work for particular effects with pastel are watercolor papers, some printmaking papers and some handmade papers. You have to try each one to see if it lends itself to your own style of painting.

Never buy just one sheet of good paper. That one sheet of paper seems more and more important and more and more expensive the longer you look at it. If you do finally get up the courage to paint on it, you will probably find yourself focusing more on the paper than on the painting. I suggest you build up a good supply of high-quality paper. Whenever you have a little extra money, buy a few sheets of special paper. When someone asks what you would like as a birthday gift, request good paper. Accumulate enough paper so that ruining one sheet won't seem like a crisis.

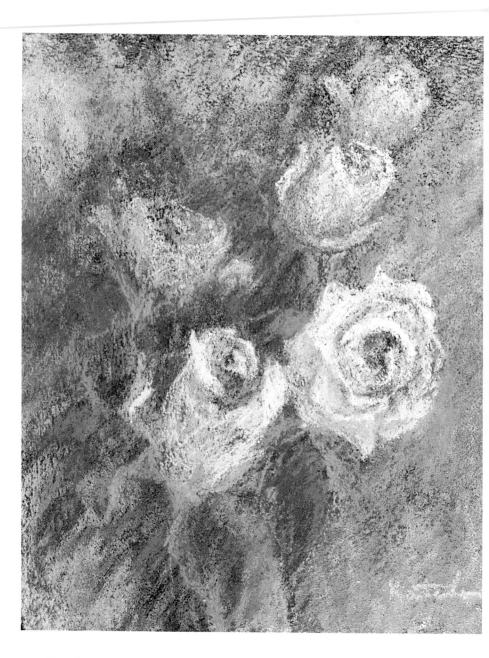

Choosing a rough surface

I started "A Classic Moment" (14 x 12" or 36 x 31cm) on a sheet of museum board coated with fine pumice ground from Golden Paints and toned with dark blue acrylic. Because of the very rough surface, it took a long time to build up solid-looking color. I applied many layers of hard and then soft pastel. When the surface texture was so saturated that it wouldn't accept any more pigment, I sprayed with workable fixative and added more layers of color. The resulting image is a mass of tiny bits of color that coalesce at a distance.

For a stronger and less mechanical tooth, there are many pastel papers and boards created with a sanded surface. The paper generally is coated with a layer of gesso or acrylic gel mixed with ground pumice or silica. This sanded surface tends to grab each stroke of pastel and hold it in place. It works extremely well for artists who paint in an impressionistic style with individual strokes sitting mosaic-like on the surface.

The limitation of the roughly sanded papers and boards is that they inhibit blending. I remember working on a piece of sanded paper that didn't seem particularly coarse when I began. As usual, I did a lot of blending with my fingers and by the time I finished, the top layer of skin had been rubbed right off. The one exception is Colourfix paper by Art Spectrum. It has a very smooth surface of ground silica that holds the pigment but also allows for easy blending.

Beware of industrial sandpapers. They are made of acidic papers and non-permanent glues. In time, the paper can disintegrate and the sand fall off, taking your painting with it.

Test sanded surfaces first for moisture resistance before you apply a wet underpainting. I remember working outdoors on a hot day. Drops of sweat fell from my forehead onto the pastel board I was using. The glue holding the fibered surface dissolved from the moisture, leaving slick white spots behind.

Make your own pastel boards
Artists who want to prepare their own sanded papers or boards have many choices. You can mix ground pumice into gesso or acrylic gel and coat a heavy sheet of paper or board. Also, you can buy a wide variety of pre-mixed grounds from Golden Paints or Art Spectrum, then brush or roll them onto the surface of your choice. You can tint the ground to the color of your choice by adding a small amount of acrylic paint to the wet mixture. Colourfix ground comes in a variety of colors.

If you want a rougher surface, use the ground undiluted. Applying the thick ground with a brush can give your surface the texture of paint strokes. For less pronounced texture, dilute the ground with a small amount of water, and brush or roll it on with a brayer. Experiment with different methods of applying the ground to find what works best for you.

There are many different kinds of boards you can choose to coat. Watercolor paper, acid-free mat board and Masonite are some of the most popular. If you use Masonite, be sure you have a thick coat of acrylic ground to serve as a barrier between your pastel and the wood material.

I caution artists against using cheap or unknown papers. Most papers and boards are made from wood pulp. The wood has a high acid content and, in time, this acid will cause the paper to yellow and eventually disintegrate, destroying your painting. The better papers usually are made without acidic content. If you have a question about the permanence of a particular paper or board, contact the manufacturer, a reputable art-supply dealer or, best, an art conservator.

Many beginners are reluctant to spend the money necessary for good paper. It can be expensive, but I always ask, how will you feel if you create your most brilliant painting on a piece of paper that is going to rot? For those of us who make a living selling our artwork, I think we owe it to our collectors to give them images that are as permanent as we can possibly make them.

REFRESHER COURSE
MAIN LEARNING POINTS IN THIS CHAPTER

1. The color of your paper will affect the apparent color and brightness of your pastels. It is easiest to paint on medium value, neutral colors.

2. The texture or tooth of your paper is what holds pigment in place.

3. Textured papers can give your finished painting a more interesting color surface.

4. Sandpapers are especially good for holding definite strokes, but they usually are not good for blending.

5. It's worth investing in high-quality paper. Cheaper papers are rarely permanent. The color may fade or yellow and, in time, the paper itself might disintegrate.

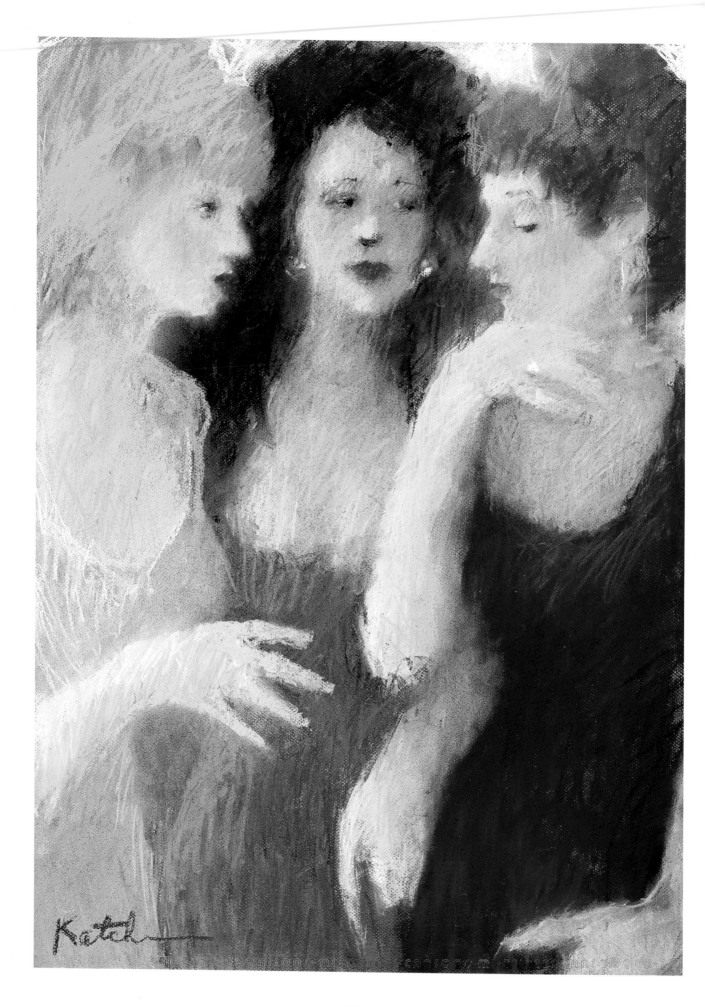

MANY PASTELISTS DISAGREE ON THE MERITS OF SPRAY FIXATIVE, BUT HERE'S HOW YOU CAN USE IT TO YOUR ADVANTAGE.

What you need to know about fixative

Because pastel pigment goes on dry, there are no chemicals holding the pigment in place. It is therefore susceptible to the effects of gravity, static electricity and any kind of jarring movement. Since the earliest use of pastels, artists have been looking for a protective fixative that would permanently hold the color particles in place without changing the appearance of the painting. Although modern materials come closer to meeting these criteria, it still takes a bit of know-how to use them properly.

Weigh the alternatives

Degas is said to have steamed his finished pastels to make them more stable. Other artists have used a wide variety of varnishes. Unfortunately, even the most modern fixatives change the painted surface to some extent, altering the color and light refraction.

I know artists who don't use fixative at all. They shake their finished paintings, pound on them and do anything else they can think of to remove loose pastel dust. Unfortunately, gravity and static electricity from the protective glass still cause pastel particles to fall away from the painting over time. I have even heard of static electricity causing the entire image to be transferred from the paper to the glass.

Thus, I highly recommend the use of fixative to protect a finished pastel painting. Several very light coatings of spray fixative will help stabilize the pastel with a minimal amount of alteration to the surface.

Apply fixative correctly

I always use "workable" fixative so that I can make changes after it has dried. I begin by standing the painting upright on a drawing board. I shake or tap the painting to remove loose pigment. Then I shake the can of fixative vigorously before spraying. I hold the can about 18" from the upright painting surface and move it in a slow, regular pattern back and forth across the entire painting. I go past the edges so that the fixative will neither miss the edges nor be heavier there. Sometimes I add another coat moving my arm up and down from the top to the bottom across the entire surface. This helps to ensure that I haven't missed a spot.

Some small dark spots may appear on your painting surface even though you have taken every precaution. These can usually be eliminated by lightly rubbing a drawing stump or fingertip over the spot after it dries. In the worst case, where you spray too heavily and get a spot that looks like shiny plastic, you can carefully rough up that area with sandpaper and reapply pastel.

Another aspect of applying fixative correctly involves taking the proper health precautions. Every kind of spray fixative I have found is highly toxic. I use the aerosol spray cans because they are most convenient, but unfortunately, they put innumerable particles of noxious chemicals into the air. To use the aerosol type effectively without harming yourself, I strongly recommend that you only spray outdoors, wearing a mask or respirator

Re-thinking the content
"Summit Conference" (29 x 21" or 74 x 53cm) began as a demonstration for a workshop. Working from a live model, I painted the figure in the center. Later I decided the painting needed more content. I sprayed the entire surface with workable fixative to stabilize the color and restore tooth to the surface so I could add two more figures.

while you spray. Then allow the painting to remain outdoors until the fixative has dissipated. One alternative is a mouth atomizer, a device through which you blow fixative onto your painting. This emits less airborne particles, but I assume it's harder to control. I have never tried it.

Believe it or not, I prefer fixative with a strong odor so that I won't forget its' poisonous qualities. Unfortunately, most of today's manufacturers are pushing odorless fixative. Whether it smells bad or not, never forget that spray fixatives are highly toxic.

Spray repeatedly throughout the process

It's true that spray fixative will alter the appearance of your pastels, but you can use this to your advantage. To minimize changes in the finished painting, I suggest spraying with workable fixative several times during the course of a painting. Sometimes I spray when I get my initial drawing right, protecting the lines and values as a guide to my later painting. Then I might spray again when I get the basic colors blocked in. Sometimes I just think, "Hm, I haven't fixed the painting for a while", and I take it outside and spray it.

The most common change that occurs from spraying fixative is the darkening of colors. Occasionally I lose some of my lighter areas altogether. When that happens, I simply repaint the light areas. I fix again with a very light coat of spray. I continue this procedure until the finished values are exactly what I want them to be.

Take advantage of the benefits

Many pastel artists think of fixative as a necessary evil. Not me. I have learned to use it as one of my most effective painting tools. If the color in a passage is too soft, I spray it to make it darker or more intense. If I decide I don't like one area of a painting or perhaps the whole thing, I spray with workable fixative to stabilize the color and restore the tooth, enabling me to begin again. The old painting becomes an underpainting, and I can start over on the same surface.

I have also found that spraying many layers of a painting can be a great way to build up an interesting surface. Look at the painting "Private Thoughts" on page 47. It looks almost like a fresco, the kind of painting where the artist painted directly onto wet plaster. This interesting surface texture was the result of alternating many layers of pastel and workable fixative.

ART IN THE MAKING

BECAUSE FIXATIVE ALLOWS YOU TO CORRECT MISTAKES, YOU'LL FIND IT EASIER TO BE ACCURATE WHEN YOU WANT OR NEED TO BE

This painting was initiated by my nephew Max. Just before his *bar mitzvah* celebration he asked if I might ever do a painting of a bar mitzvah. I answered, "Sure, just don't tell your Mom. We'll give it to her as a surprise". Because it was basically a portrait, my challenge was to capture a likeness as well as create a good painting. Likenesses are not my strong suit, but with the help of workable fixative, even the likeness was a success. I used Unison and Holbein pastels on black Hahnemuhle paper.

TIP 4

Some spray nozzles work better than others. The worst nozzles throw little globs of fixative onto the painting, leaving shiny dark spots. To avoid this calamity, I test a fresh can of fixative by spraying onto a sheet of scrap paper. The spitting effect shows up in my preliminary test. If I see a problem, I change nozzles. The little plastic tip can easily be replaced by nozzles saved from cans of fixative that worked well.

Taking visual notes
I took several snapshots of Max to use as reference material, and I concentrated on remembering as much of the actual scene as I could.

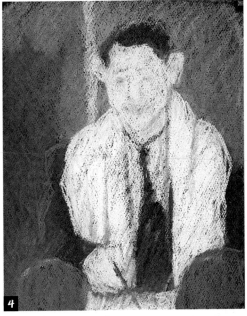

Sketching the composition
I created problems for myself right at the beginning by not taking enough time to plan the painting. But not realizing this because I was more concerned with general composition than accurate rendering, I quickly sketched the subject and moved ahead.

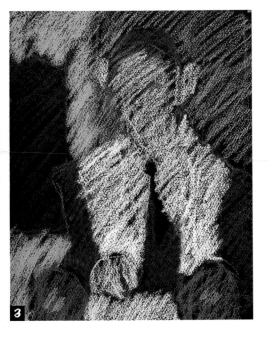

Blocking in the shapes
I loosely blocked in the large color shapes with quick, hatched strokes.

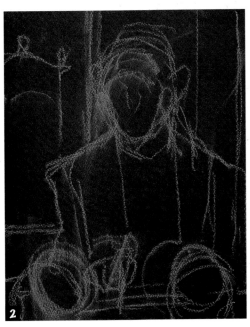

Stopping for a breather
I continued to build up the painting by cross-hatching with more layers of the same and similar colors. I was working with fairly soft Unison pastels and noticed that the colors were getting dense. I was tired and dissatisfied with the painting, so I left the studio for the day.

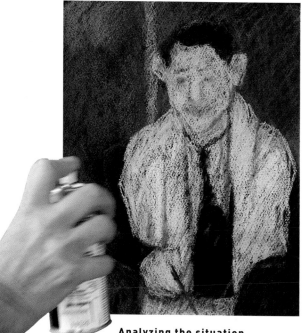

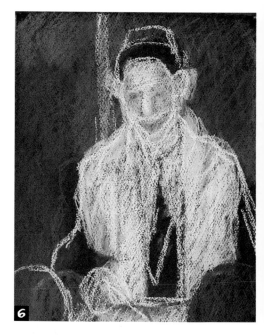

Analyzing the situation

The next day I came back with a fresh eye. When I stood back, I saw that the shapes looked heavy and clumsy, but the biggest problem was the head. It was too big and I had completely lost the wonderful pixie chin that typifies Max. I sprayed the painting with workable fixative.

Revising the drawing

I now had a fresh painting surface, which made it easy to alter the painting. I drew new contours over the existing painting.

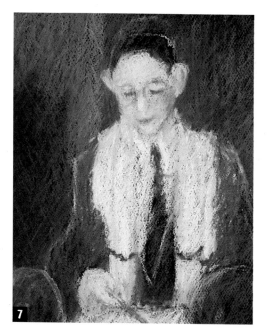

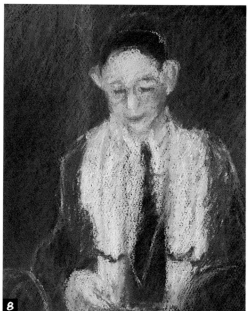

Choosing the right pastels

I switched to harder Holbein pastels. The harder pastels would go on more slowly, forcing me to be more deliberate in my application of color.

"Fixing" the values

I liked the general color, but the values weren't deep enough. I resprayed with fixative to darken the colors.

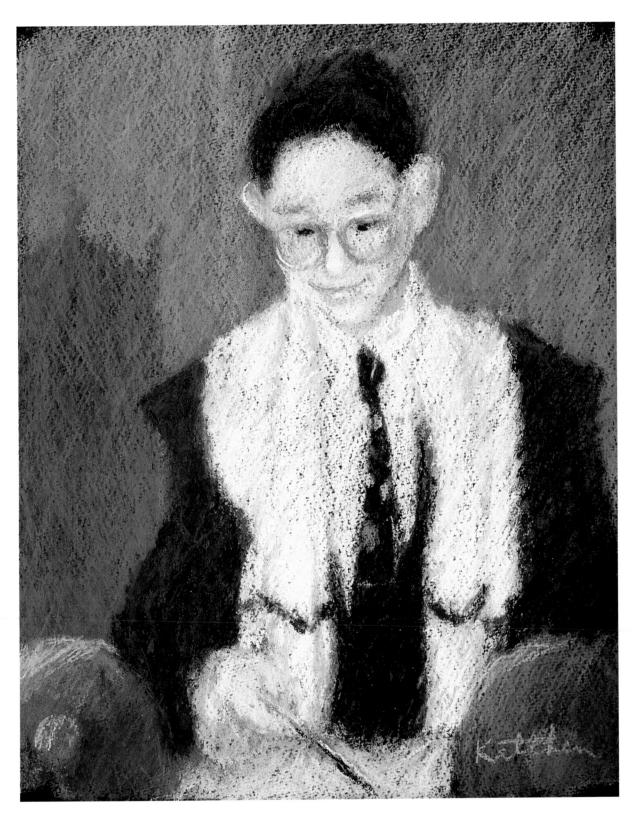

Stopping at the peak of perfection

I continued to refine shapes and colors with thin layers of hard pastel strokes. Finally I felt I had captured Max's appearance and personality. I was also pleased with the overall color and composition, so I stopped before "Max's Bar Mitzvah" (13 x 11" or 33 x 28cm) could become stiff and clumsy again.

USING WORKABLE FIXATIVE ALLOWS YOU TO RE-WORK A PAINTING AGAIN AND AGAIN UNTIL YOU'RE SATISFIED

I often finish a painting, sign it, spray it and photograph it. Then some time later I decide it is not the best I could do. With the help of workable fixative, I am able to go back and rework it. Here are three states of the same painting. I was painting with Sennelier pastels on a sheet of gray Fabriano Morillo paper.

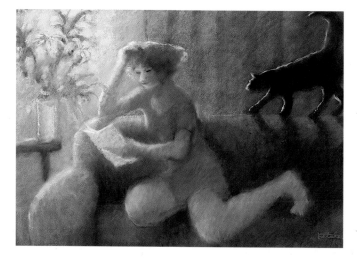

Sketching from life
Originally, this painting was based on a sketch of a friend sitting on a sofa with light coming from a single source. The cat happened to walk across the sofa as my friend sat there. In this version, I was happy with the light, but I later decided the figure was much too awkward.

TIP 5

Keep the spray can moving. If you hold the sprayer in one place for too long or if you hold it too close to the surface of the painting, you can get a slick, hard spot. By maintaining your distance and constantly moving the can, you will get an even coating of fixative.

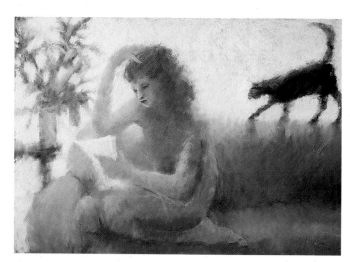

Switching to backlight
After I sprayed with fixative, I redrew the woman, brightened up the colors and moved the light source further behind the figure. I especially liked the back-lit cat and the modeling of the sofa in this revision, but I decided that wasn't enough to justify saving the image.

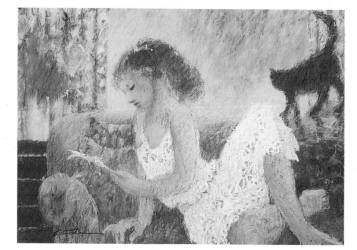

Adding more color and pattern
I sprayed again. I made the woman more graceful. The light was now coming from a window directly behind the sofa. I added curtains, pillows and a lace skirt and camisole, giving more opportunities for color and pattern. The original texture of the paper was completely gone by now, replaced with a rougher, sand-like finish. This allowed for several new layers of strokes to develop more interesting colors and textures. I might have reworked this third version of "The Love Letter" (27 x 39" or 69 x 99cm) again, but it sold before I decided to do so.

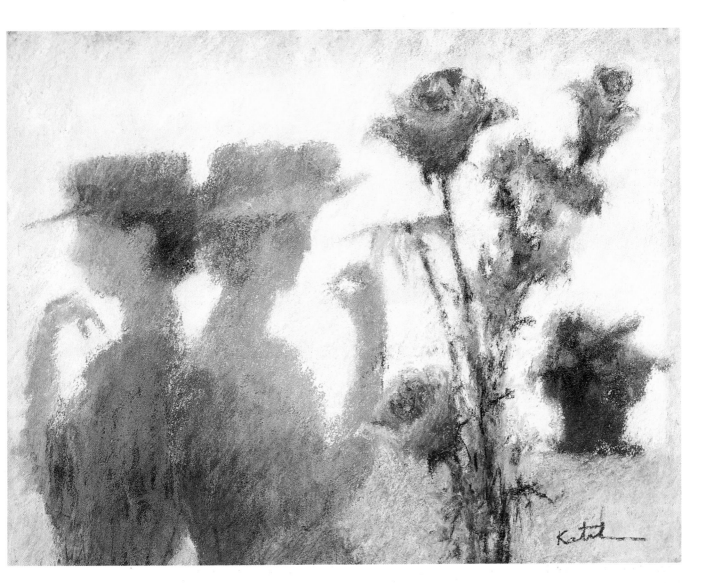

Altering the surface

"Private Thoughts" (19 x 25" or 48 x 64cm) was done on Canson paper, but I reworked and re-sprayed it with fixative so many times that it developed a different surface. The texture of the finished painting looks like sandpaper. It breaks the pastel up into tiny little spots of color, creating an effect almost like the old Italian frescoes.

A SUPPLY LIST FOR PASTELISTS

So far, we've covered the essential materials you'll need to be more expressive in your pastel paintings. These materials are:

1. Pastels

Start off with between 20 and 50 sticks of pastel. These should include a variety of harder and softer pastels. Do not choose the cheapest brands, thinking you will save money and it won't make any difference. Trust me, it makes a big difference! Painting with professional quality pastels is a totally different experience than painting with student quality.

Colors should include a selection of primary and secondary hues — red, yellow, blue, orange, green and purple. A couple of browns are good, especially if you paint landscapes. Aim for a wide range of values, too — from very light, almost white, to very dark, almost black. I generally avoid pure white or pure black.

2. Paper

At least 10 sheets of pastel paper. They should be full sheets, at least 18 x 24" (46 x 61cm). Choose a variety of hues, preferably natural tones in middle values. As you get more experienced, you can try the more dramatic colors and black. Remember that white paper is the most difficult to use.

3. Fixative

A can of workable fixative. I prefer Blair because it restores the tooth quickly, but there are many reputable brands that might suit you as well or better.

4. Paper towels

I always keep a roll of soft paper towels handy. They are useful for blending large areas of color and also for wiping out mistakes.

5. Easel, drawing board and clips

I recommend standing at an easel when you paint with pastels. Standing gives you freer movement of your drawing arm. It also allows you to move back and forth from the easel to assess your painting more clearly. Perhaps most important, it allows you to keep some distance from the falling pastel dust. If you work on a table leaning over the painting, you will breathe more of the pastel dust directly into your lungs than if you work upright at an easel.

6. Optional tools

There are many devices that can be helpful. A stiff-bristled brush is good for removing unwanted pigment from a section of a painting. Where the pastel pigment is thin on the surface, I like to use a kneaded eraser to remove unwanted color. I also use the eraser as a drawing tool, drawing through a thin layer of pigment to allow the original paper color to show through. I also have a few drawing stumps (pencil-shaped rolls of paper) for blending or altering tiny details.

7. Health aids

Artists who are worried about the effects of breathing pastel dust can wear a face mask or respirator. If you are concerned about pastel pigment on your skin, you can wear latex surgical gloves or barrier cream while you work.

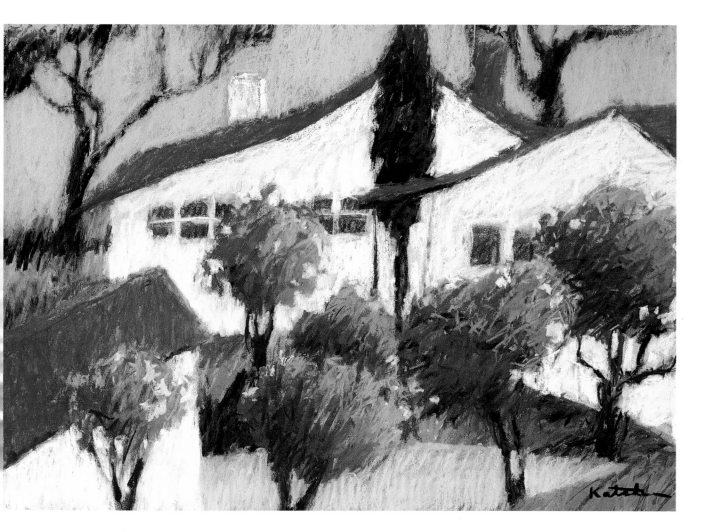

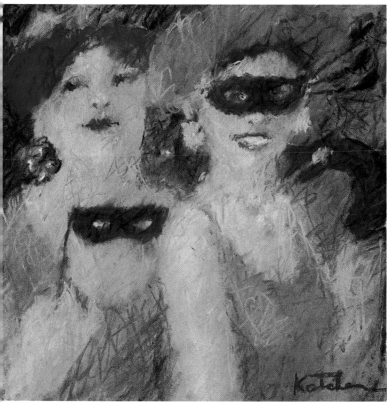

Hitting the road
"The President's Ranch House" (18 x 26" or 46 x 66cm) is one of the paintings I brought back from a trip to the California ranch of Ronald Reagan. To get the intensity of white stucco in the sun, I painted several layers of light yellow, light purple and light blue strokes, spraying with fixative between each layer.

Keeping supplies to a minimum
Because of the richness and versatility of pastels, you don't need a vast selection of colors and other materials to complete a painting such as "Masquerade" (14 x 15" or 36 x 38cm). Spray fixative is, in my opinion, one of the few essentials.

49

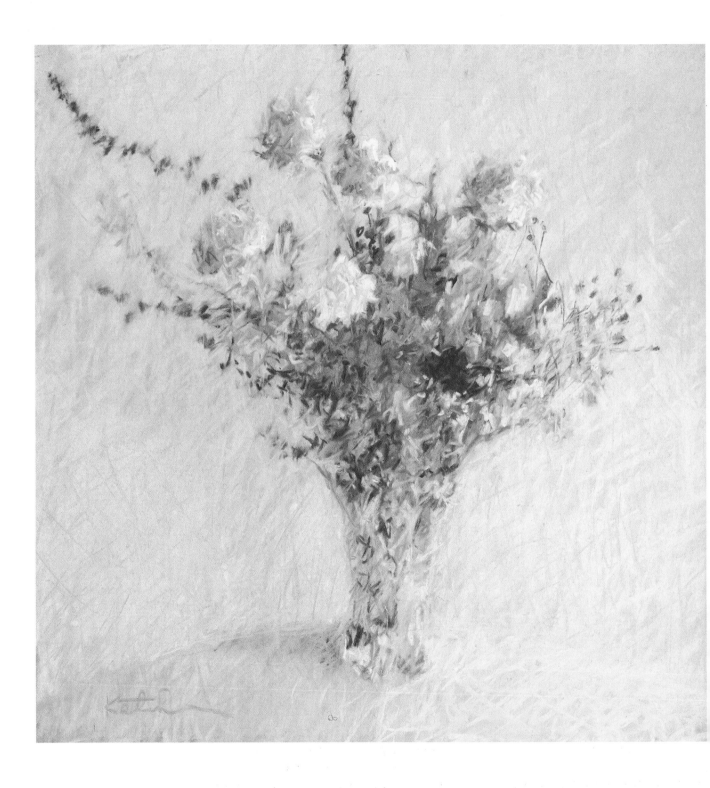

LEARN HOW TO MAKE YOUR STROKES REFLECT YOUR PERSONAL STYLE AND ENHANCE THE MOOD OF YOUR PAINTING.

What you need to know about applying pastels

Every stroke of color you make with pastel is important to the finished painting. Are the marks thick or thin, heavy or light, curved or straight, regular or random? Each stroke helps to define the image, but it also affects the total design and mood of the piece. This means that the way you make marks on the paper can be deliberately designed to help express your individuality in your paintings.

In order to have the greatest control, try out a variety of strokes before you begin your painting. Try straight lines, curved lines and dots of color. Try heavier pressure and lighter pressure. Use the tip of the pastel and the unwrapped side of the stick. Try every kind of stroke you can think of. Then, whatever it is you want to achieve in a painting or in a passage of a painting, you will have the tools to do so.

Your pastel strokes also express your personality and approach to painting. When I begin to teach a new workshop, I can tell a tremendous amount about each student just from the first few strokes of pastel. I can tell who's shy, who's confident, who's timid, who's practical just by watching them apply color to their paper.

Render with realistic strokes

If your main concern is precision, your strokes should be slow and thoughtful. Harder pastels will give you more control, especially when sharpened to a point. Your strokes can be short or long, but they probably should reflect the shape or contour that you are trying to render. Don't use straight lines to convey a curving lakeshore or a puffy cloud.

If you are striving for natural realism, you will be best off with small dabs of color that don't have an obvious shape of their own. Definite straight or curved lines tend to sit on the surface of the image rather than blending into it. Similarly, strokes that have a formal or regular shape — circles, rectangles, triangles — take on an obvious presence. For the most realistic images, your strokes should be as unobtrusive as possible.

For three-dimensional forms, especially trompe l'oeil, the strokes themselves should be virtually invisible. This can be achieved through many small, overlapping strokes of harder or softer pastel. Layering many light strokes also hides the individual marks.

Make impressionistic marks

Most impressionistic paintings rely on visual blending, meaning the separate strokes of color appear to merge when viewed from a distance. For an impressionistic effect, the individual strokes should be distinct.

Some of the French Impressionists used a technique called "hatching". This means covering an area of color with parallel, often diagonal, strokes. It is best if these are rather quick, irregular strokes. Very straight, regular strokes don't appear to blend into the image quite as well.

A similar technique is "cross-hatching". This means layering parallel strokes with each layer going in a different direction.

Matching stroke to subject
In the best pastel paintings, the nature of the strokes reflects the character of the subject. In "Memories of Love" (17 x 17" or 43 x 43cm), my subject was dried roses and wildflowers in a cut crystal vase. Everything was angular and brittle, best reflected with quick, broken strokes of color.

For instance, the bottom layer might be vertical strokes, the next layer horizontal, the next diagonal and so forth. Add as many layers as you need in order to get the color and density required.

This is a great technique for mixing colors. By alternating layers of blues and yellows, you can achieve interesting greens, for example.

Two other techniques I enjoy are scribbling and stippling. With scribbling, I add layers of irregular, scribbled lines until I have filled the section with color. Stippling, a technique often associated with the French Post-Impressionist Georges Seurat, means applying layers of dots of color until the area is completely covered with pigment. With either of these approaches, as with hatching, the area of color looks solid from a distance, but up close the viewer can distinguish the individual strokes.

The types of marks that can be used for visual blending are virtually unlimited. Any kind of dot or line can be repeated in an area until it takes on a density that blurs into solid color at a distance. What's more, I have found that my collectors enjoy visual blending because they can see something of the painting process in the finished work. It allows them to feel they are participating in the painting.

Go wild with expressionism

Traditionally, Expressionists are most committed to the emotional impact of a work. Pastels are ideal for these intuitive painters.

For the artist who is not concerned with accurate rendering or three-dimensional form, there are absolutely no limits to the marks you can use in your painting. Heavy, bold lines of color always have a strong, dramatic impact. Decorative strokes

and patterns are great ways to add joy and whimsy to an image. Try scalloped lines and zigzagged lines. Use the pastel stick on its side for wide lines. Use it on the edge for thin lines. Let your imagination go wild.

Use the right touch

One of the hardest skills for new pastel artists to acquire is the ability to control the amount of pressure used for each stroke. Insecurity tends to push them to extremes.

The more timid artists use almost no pressure. This is a problem if they are working with harder pastels. Each of their strokes is so light that it barely shows up on the paper. There are times when a light touch is called for, especially when you are working toward a very accurate, realistic image. In most instances, however, pastel works best with firm, definite strokes. Don't worry about making mistakes

Getting to the point
For thin lines, turn the end of the pastel stick so that you are drawing with just the sharp edge.

Standing on end
For medium lines, hold the stick so that its flat end rests on the paper. Your line will be as wide as the diameter of the pastel stick.

— I'll tell you later in the book how to fix anything.

Other new pastelists press the unfamiliar pastels so firmly that harder sticks make grooves in the paper and softer sticks literally crumble in their hands. The problem with this heavy-handed approach is that you can waste an enormous amount of paper and pastel pigment.

I suggest you practice making a variety of strokes until you are confident of the amount of pressure to use. Take a pile of scrap paper and make pages of light strokes, medium strokes and dark strokes. Use soft, medium and hard pastels. Pay attention to how the pastel stick feels in your hand. Keep working until you can predict how dark a stroke will be before you make it. The most successful pastel artists have a full range of strokes they can use for different effects.

Minimizing the appearance of strokes

For realistic painting, the strokes themselves should be as unobtrusive as possible. In "Ladies in Waiting" (25 x 19" or 64 x 48cm), some of the individual strokes are visible, but for the most part, the strokes are secondary to the image.

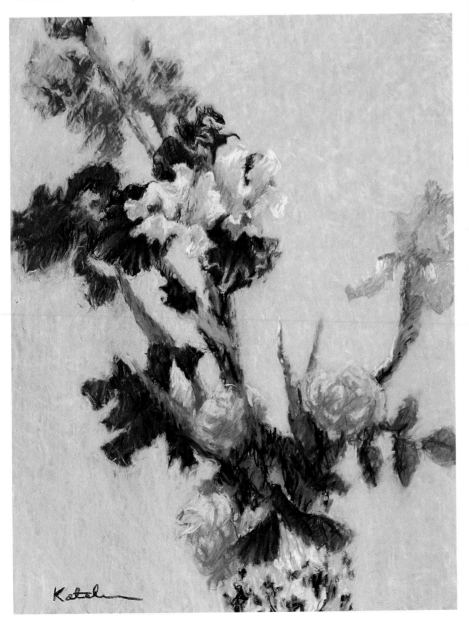

HOW TO HOLD A STICK OF PASTEL

Pastels generally work best when held between the tips of the thumb and the first two fingers. This encourages you to draw with your entire arm and shoulder, giving you a broader range of movement and expression. If you hold the stick like a pencil, between the thumb and first finger, resting against the middle finger, your movement is restricted to just the wrist.

Hold the pastel stick between the tips of your thumb and your first two fingers.

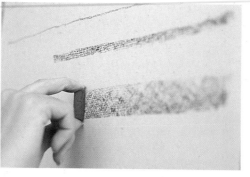

Living on the edge
For wide lines, turn the stick of pastel flat on its side. Some artists immediately remove the paper label from new pastels and break the stick in half so that they can use it for this type of thick line.

TIP 6

To get a fine point on a stick of pastel, sharpen the end by shaving it to a point with a sharp knife or sanding it to a point on a sheet of sandpaper.

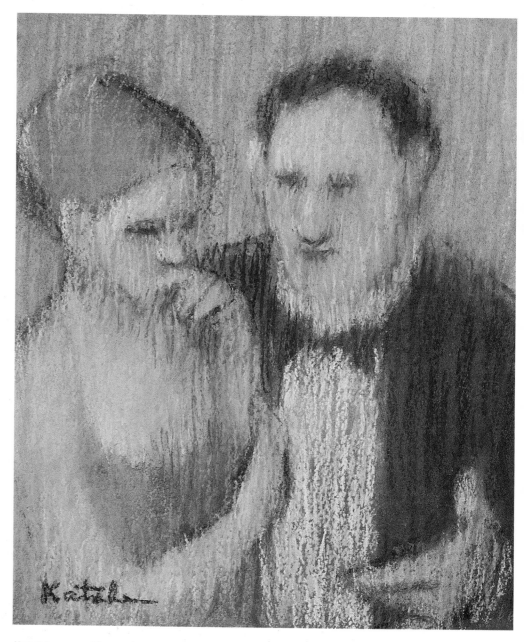

Hatching over the surface
The type of strokes used to apply pastel to a surface has a lot to do with the character of the finished painting. "Trouble in Camelot" (14 x 12" or 36 x 31cm) was created with repeated vertical lines of color, or "hatched" lines. From a distance, the strokes blend together so that the viewer sees only the subject, but up close the strokes themselves add to the visual interest of the piece.

Mixing strokes for effect
To create the effect of transparent cloth in "Dancer in the Spotlight" (39 x 27" or 99 x 69cm), I lightly went over existing colors with the flat side of the pastel. The textured paper allows bits of the previous color to show through the top layer.

THE WAY YOU APPLY PASTEL HAS A PROFOUND EFFECT ON THE FINISHED PAINTING, SO EXPERIMENT WITH THESE THREE APPROACHES

APPROACH 1: SCRIBBLING
APPROACH 2: STIPPLING
APPROACH 3: BLENDING

I have taken a simple egg as my subject for each of these three demonstrations so you can easily compare the end results. I placed the egg on a table top with one bright light shining on it from the right. The intense highlight and shadow is what gives each painting its dramatic punch.

THE SCRIBBLING APPROACH

Scribbling the underpainting
Using hard Holbein pastels in the complementary colors yellow and violet, I indicated the general shape and location of the egg and its shadow. I used scribbled strokes for thin layers of color on the black Fabriano Morillo paper.

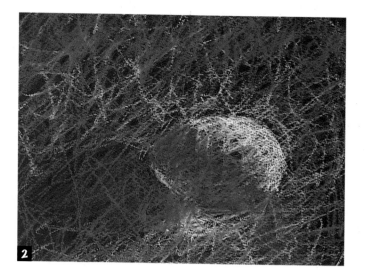

Overlapping complements
I covered the whole format with color. I added blue-violet in the deepest shadows and at the top of the background, a very light yellow ochre for the highlights and a deeper yellow ochre in the background. Overlaying the complementary colors created a soft, neutral tone for the finished piece. It is warm because the predominant colors — ochres and red-violet — are warm.

56

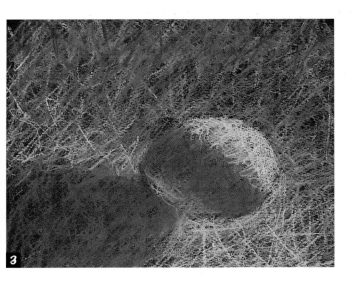

Going for correct values

I added more and more layers of scribbled strokes, constantly comparing the painting with the actual object in front of me. I especially studied the values because that is what will create the roundness of the egg and the drama of the lighting.

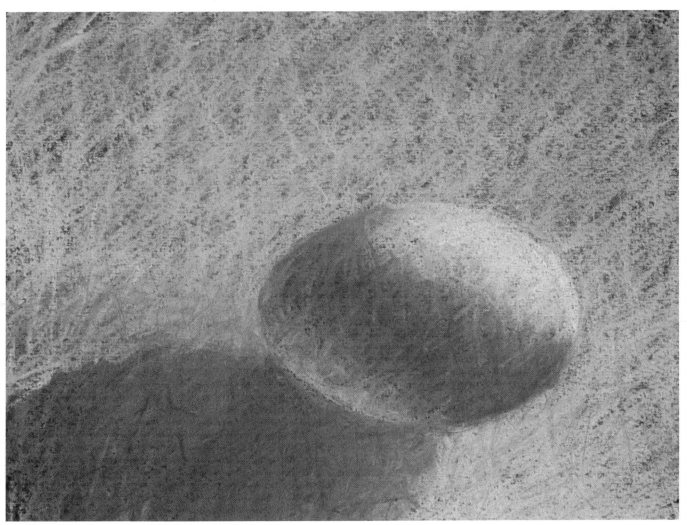

Merging the scribbles

To finish "The Scribbled Egg" (7 x 11" or 18 x 28cm), I added strokes of a few more colors — pink, green and red. I placed the new colors by value — darker red and green in the cast shadow, light pink in the background. I used a light touch with the new colors, adding just enough to increase the richness of hue, but not enough to take the eye away from the subject. At this point, there were so many scribbled strokes that the eye can no longer pick out individual lines. Instead, you just see the general colors and values.

THE STIPPLING APPROACH

Starting with dots
As always, my initial concerns were shape and value. I chose three colors of different values — very light blue, medium green ochre and dark red — from my set of soft Unison pastels so I'd have strong color. With dots, I located the main shapes and values.

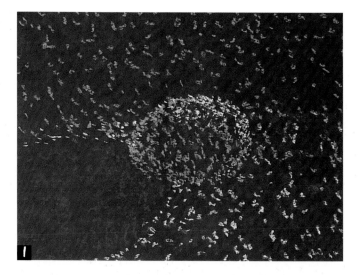

Building layers slowly
I added more dots of the same colors to make the colors denser. Since there were no outlines, it was important to work carefully so that I didn't lose track of the main shapes. I stood back from the painting periodically to see how the colors and values were developing.

Intensifying the color
More dots! (I have decided that this is a perfect approach for an obsessive-compulsive personality because it's repetitive, but takes constant vigilance.) I added a warmer ochre to the areas of middle value. It was essential to keep standing away from the easel to assess the overall image.

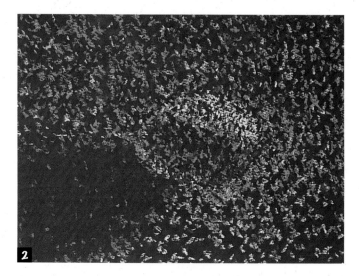

Harmonizing the results

In the final stage, I went a little wild with colors, such as blue, green, red and purple. I added the colors randomly, taking care only that the values were consistent with what was already there. I made sure I added dots of each color throughout "The Dotted Egg" (7 x 11" or 18 x 28cm). Notice the bits of red in the cast shadow, in the shadow on the egg and in the upper right background to unify the painting. I could have added even more dots and gotten a smoother surface, but I had achieved my goal and I was beginning to go a little nuts from this, so I stopped.

THE BLENDING APPROACH

Working the background

I placed the big shapes with outlines, then hatched in the negative space, using a variety of fairly soft pastels. I used more pressure to get brighter strokes of medium yellow ochre on the right edge of the egg where the light was strongest. It looked very light because of the contrast with the black Fabriano Morillo paper.

Blending the background

Next, I wiped the entire surface with a paper towel. Then I used a kneaded eraser to pull pigment off the shadowed areas, restoring them to a very dark value. One advantage of black paper is that you can use its darkness to help create your deeper values.

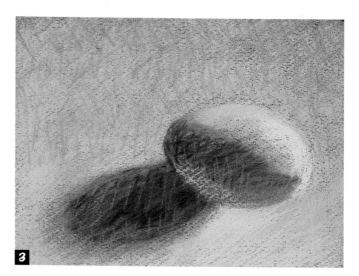

Expanding the value range

I added more of the same colors and blended them together. Then I expanded the range of values with a very light ochre, medium mauve and dark olive green. I stuck mainly with the complementary ochres and purple to keep the colors neutral; blending complements together grays the color. I used very light strokes, which I carefully blended together with my fingertips.

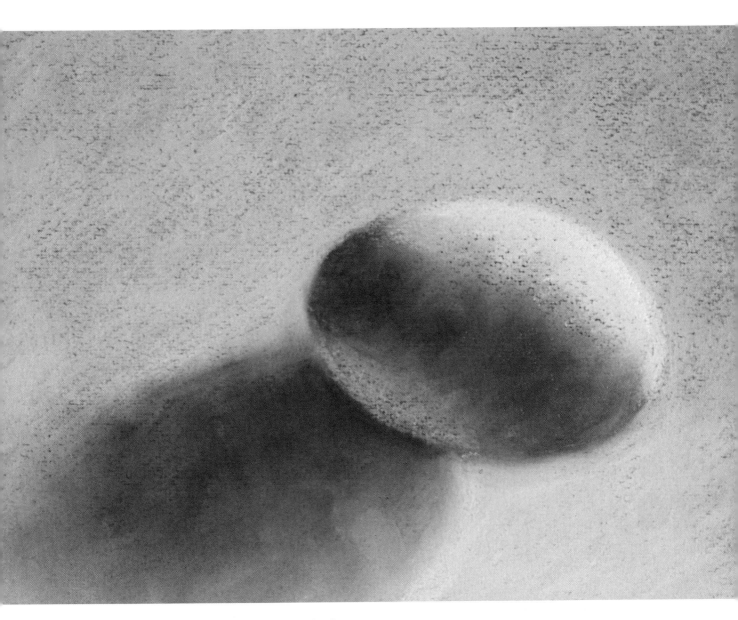

Refining the shapes and values

To finish "The Blended Egg" (7 x 11" or 18 x 28cm), I added light strokes of the same colors to refine shapes and values. For this kind of realistic rendering, I had to keep referring to the subject in front of me, often squinting my eyes to judge the values more clearly. I blended the final strokes with the tip of one finger, taking care to eliminate any outlines or hard edges.

ALL 3 APPROACHES

Suggesting energy
This is a great example of visual blending. Up close, the scribbled lines form a complicated network of interwoven colors. However, from a distance, the individual strokes blend together for a smooth, solid surface with a subtle touch of energy.

Avoiding overkill
With very distinct strokes, such as these dots, the technique of a pastel painting can be as interesting to the viewer as the subject. The danger is that the marks of color can overpower the subject. It is important to keep standing back and looking at the image as a whole while you are painting.

Achieving a smooth look
When you blend away the strokes, the subject itself becomes paramount. Thus, it becomes especially important to establish value distinctions because there are no lines to indicate shapes. With the intense value contrast here and no strokes to distract the eye, the egg seems to glow.

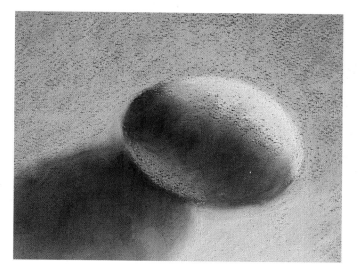

Capturing the feeling
To keep the painting from appearing too regular and mechanical and to create a more organic feel suitable for this landscape subject, I applied my color in strong hatched strokes. The soft Unison pastels filled some of the tooth of the Fabriano Titziano paper, giving "Fork in the Road" (16 x 22" or 41 x 56cm) a more interesting surface.

REFRESHER COURSE
MAIN LEARNING POINTS IN THIS CHAPTER

1. The type of strokes you make will affect the mood, depth and precision of your image.

2. For natural realism, your strokes should be as unobtrusive as possible.

3. For Impressionism, use visual blending. Cover the surface with separate strokes of color. From a distance they will appear as solid color, but up close the strokes provide interesting texture.

4. Techniques for visual blending include hatching, cross-hatching, scribbling and stippling.

5. For Expressionism, use strokes with more character. Heavy, bold lines of color will add drama. Patterned lines and decorative shapes will add whimsy.

6. The pressure of your strokes affects their value. Soft strokes are lighter; heavy strokes are darker.

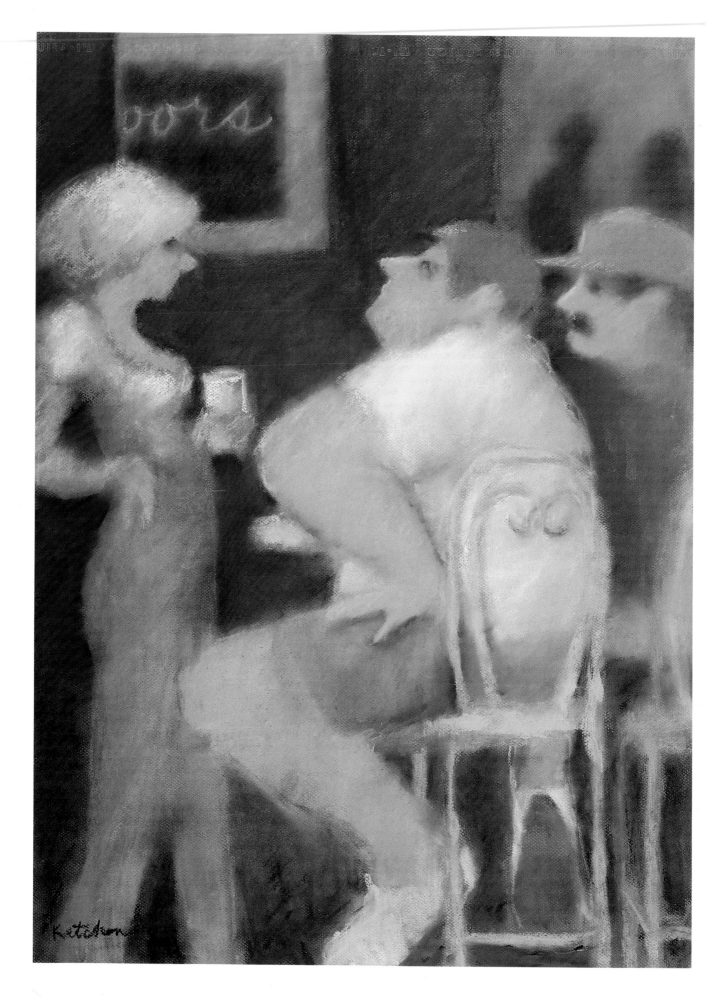

BLENDING MAY SEEM SIMPLE, BUT YOU NEED TO KNOW JUST
WHEN AND HOW TO DO IT TO GET THE EFFECTS YOU'RE AFTER.

What you need to know about blending

I have heard of instructors warning their students never to blend, saying it deadens the colors, but I personally cannot imagine being a pastel artist without blending. Half or more of my repertoire of pastel techniques involves blending. Does it deaden the colors? Sometimes, but that isn't necessarily a bad thing. One of the things I deplore about many pastel paintings is the absence of grays or grayed colors. How can the brilliant colors shine if there are no grayed colors for contrast? There is no sparkle to a painting executed in all brilliant hues.

Besides putting more variety in your colors, blending is a great way to achieve a vast range of other effects. You can eliminate hard edges, model three-dimensional forms, mix colors, erase mistakes, cover large areas with color — all with blending.

The most important thing to know about blending is this: The softer the pastels, the easier the strokes will be to blend. Strokes of very soft pastel, especially light strokes, leave the pigment sitting lightly on the surface of the paper. It takes little effort to move or blend them. In contrast, harder pastels take much more pressure to make a mark. The pigment is pushed right into the fibers of the paper. It is trapped there, fiercely resisting any attempt to move it around. If you want to blend your colors, use softer pastels and a lighter touch.

Blend for a realistic style

The most familiar use of blending is what we see in pastel portraits of children.

The artist blends away hard edges and definite strokes to show the softness of a child's skin. This technique can be used to convey any smooth surface — a ceramic bowl, for instance, or a glass vase.

This smoothness is achieved by blending every stroke or every few strokes with a fingertip or drawing stump. By blending slowly and lightly in one small area at a time, you are able to execute subtle gradations of color and value. Another technique for losing the edges and strokes of soft pastel is working over them with harder sticks of pastel. The hard sticks move the soft pigment underneath without leaving definite strokes behind.

Cover large areas

It is simple to achieve the effect of a smooth, sheer layer of color by blending. Begin by covering the desired area with strokes of soft pastel. Use only one color if you want a flat area of that color. Or, if you want color variation, change the color of the strokes from one section to another or put different colored strokes on in layers.

Lightly blend the area with the flat of your hand or a paper towel wadded into a sphere. I use a small circular movement, like polishing a car, until the entire area is covered with a smooth layer of color. Be careful not to use too much pressure with a paper towel — the more pressure you use, the more pastel will be removed from the surface. Too much pressure will leave you with a very skimpy-looking layer of pigment.

Emphasizing shapes
Blending is a wonderful option for the pastel artist. In "Two Bubbas and a Babe" (29 x 19" or 74 x 48cm), you see how blending puts the attention on shape rather than line. Also, it's a great way to create atmosphere, such as this dark interior of a tavern.

SIMPLIFY THE PROCESS OF BLENDING BY UNDERSTANDING YOUR TW

There are two general ways to blend — with a paper towel or with your hands or fingers. The technique you choose depends on the look you want to achieve. Blending by hand tends to generate a smoother effect, while the paper towel method removes more color.

Applying a layer of color
Using very soft Schminke pastels on Canson paper, I laid in rows of diagonally hatched strokes. For the sky, I used darker color at the top, gradually getting lighter toward the bottom.

Rubbing the surface
With my dry, clean fingers, I rubbed the surface, moving diagonally against the direction of the strokes. I used a circular movement, just as I would do with a paper towel. I was left with a thicker layer of color because fingers don't remove much pigment from the surface.

Adding more color
I added another layer of strokes, dark at the top to light at the bottom.

Touching up with my fingers
Again, I blended with my fingers until the surface had a rich, even color. There were still a few tiny spots of paper showing through, which I eliminated by pressing pigment into the paper in those areas with a finger tip.

Evaluating the results

The blended surface was not as smooth or dense as I wanted. I could still see bits of the textured paper showing through. If I had wanted a thinner, smoother layer of color, I could have blended with a paper towel instead of my fingers, but instead, I continued with another layer of color.

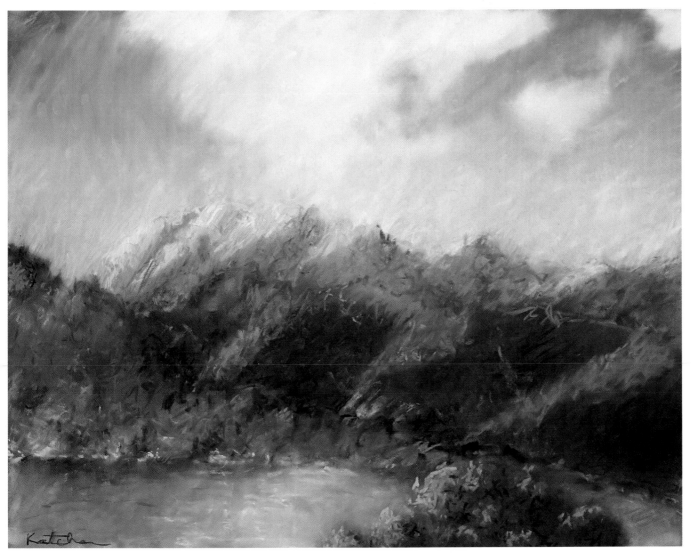

Combining techniques

Blended colors appear much more transparent than individual strokes. That makes blending an excellent technique for skies. For "Richard's View of Lake Casitas" (19 x 25" or 48 x 64cm), I blended the color in the sky, but allowed some texture of pastel strokes and finger marks to remain in order to keep the color from looking too flat. Blended areas also appear more reflective. I blended the water area to a smooth surface. Then I added some distinct marks to suggest movement in the water.

Here are some tips for a few specific situations:

1. For a sky, start with strokes of dark blue at the top. Then add strokes of lighter and lighter blue until you reach the horizon.

2. For a three-dimensional sphere, put strokes of your lightest color in the center, then add darker and darker colors until you reach the edges. (The values, of course, will be affected by your light source. The colors will be lightest where the most light is shining.)

3. For a smooth, flat floor, put strokes of your brightest color at the front, then gray the colors as they recede in space. This can be done by gradually adding strokes of the complementary color. With a yellowish floor, add strokes of violet to gray the color. For a green field, gradually add strokes of red.

In each of these instances, blend until there are no definite strokes still showing. Work all the way out to the edges of the total shape. By using a small, circular motion across the whole shape, you will gradually blend small areas of color until the whole large shape has a smooth finish.

Refine your initial drawing

I rarely get my drawing exactly right from the start. I have learned to draw quickly, then smear that drawing with a paper towel. The lines and shapes become softened enough so that I can easily draw over them. The ghost image of my first drawing is still visible, giving me a guide for refining the shapes and contours. Sometimes I use my kneaded eraser to refine the smeared drawing.

This technique has the added advantage of beginning my background color. I smear the strokes of the drawing over the entire surface of my paper. This eliminates that stark paper look that so inhibits creating a background. The more times I draw and wipe out the sketch, the denser the background color becomes. Sometimes I find myself with a rich background color already in place by the time I finish my initial sketch.

Mix colors by blending

Even with many boxes of pastels, there are times when I just don't have the right color. I have found that I can mix the perfect color right on the painting.

Say I want a very cool red, cooler than anything I already have. I apply a few strokes of my coolest red. I add a few light strokes of blue or purple. I blend the strokes together and now I have the perfect cool red right on my painting. The great thing is that I can continue to adjust colors and values throughout the painting.

THE PAPER TOWEL TECHNIQUE

Blending with a paper towel
I began with strokes of a fairly soft pastel. Then I wadded up a paper towel into a ball with no loose edges to drag across the surface. This works best with a soft paper towel.

HEALTH WATCH

Blending with your fingers is a great way to smooth out your pastel strokes. However, the disadvantage is that your fingers end up covered with pastel. Opinions on possible danger to your health from absorbing chemicals through your skin vary. I continue to blend this way, taking the

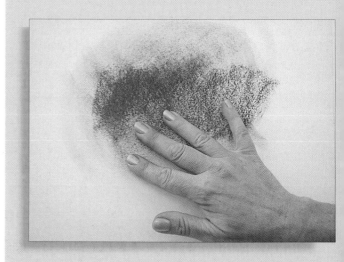

Blending directly with your fingertips is fine . . .

68

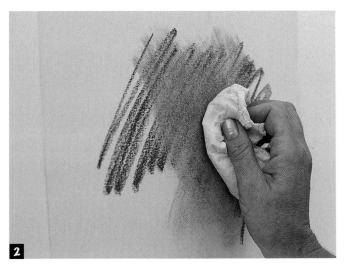

Using a circular motion

I rubbed the paper towel across the strokes. The best hand movement I've found for smooth blending is a steady circular motion.

Lightening the results

The result was a fairly even, yet still mottled, layer of pigment across the surface. The blended area was much lighter than the original strokes, partly because the pigment was spread over a larger surface and partly because the paper towel removed some pigment from the surface. I could have achieved a smoother finish by repeating the process.

precautions of washing my hands frequently and not eating or drinking anything when my hands are covered with pastel dust. Artists who are worried about pastels on their skin can try latex surgical gloves. The gloves don't move the pastel pigment quite as well as bare skin, but they do keep your hands clean.

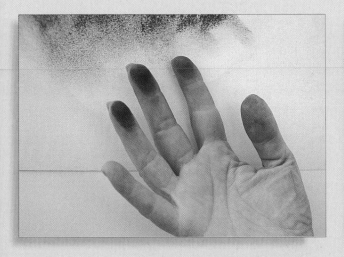

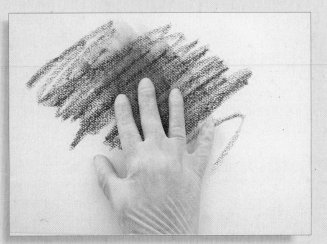

but it does grind the pastel pigment into your skin, which some artists believe to be dangerous to your health.

A good solution is to keep hands pigment-free by wearing latex surgical gloves.

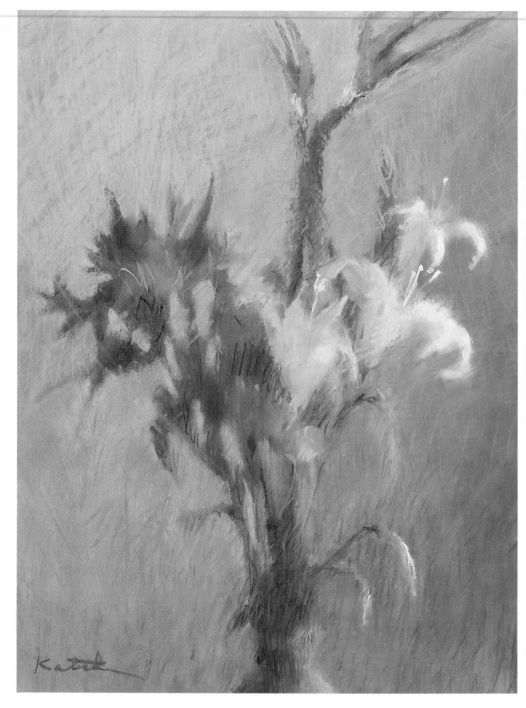

Blending for atmosphere
I have developed a great blending technique for creating soft, atmospheric florals like "Ensemble Performance" (25 x 19" or 64 x 49cm). Working with very soft pastels, I draw and blend successive layers until I am satisfied with the image. When the whole surface is covered with rich color, I simply add a few definite strokes for final details.

Before you add any color to an area where you want a hard edge to appear, press a strip of drafting tape on the outside of where you want the edge to be. Then proceed with making your strokes and blending them. When you have achieved your desired color and texture, lift the tape and you will see a precise edge. Drafting tape works better than masking or other kinds of tape because its low-tack adhesive won't pull up the fibers of your paper. This technique will not work as well on a roughly sanded board as on pastel paper. One extra note: Tape will not stick easily to an area that is already covered with thick pastel.

ERASING BLENDED COLOR

Occasionally, you may want to lift off thin layers of blended pigment. A great way to accomplish this is by using a kneaded eraser, but be sure the eraser is clean. If it has any pastel pigment on the outside, it will transfer that color to your painting. Wherever you erase, the color of the paper will show through the painting. Not only is it great for correcting errors, it can also be used to create a deliberate color effect, as in "Victorian Miss" on page 32.

I started with a thin area of color that I had blended with a paper towel.

To remove the pastel pigment from the surface, I rubbed until some of the color had lifted off.

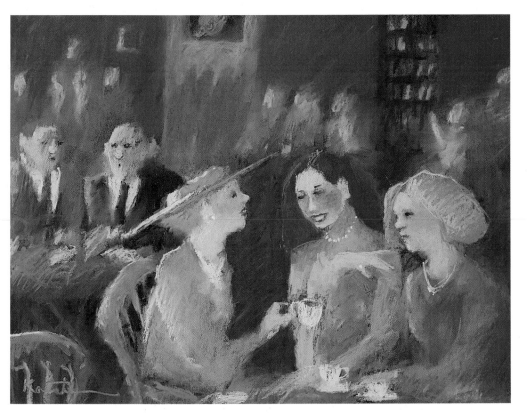

Structuring with blended shapes

What anchors all of the small elements in "Of Like Mind" (18 x 24" or 46 x 61cm) are the large blended shapes where the viewer's eye can rest. After I had established all of the larger shapes, I put in the smaller shapes and details with unblended strokes.

Loosen up a painting

Sometimes I find an image getting tighter and tighter as I paint, even though what I want is something loose and atmospheric. I try to avoid definite outlines, but they tend to show up where I least expect them. To combat this problem, I use one of my favorite blending techniques. First, I put the fingertips of one hand on the edge of the shape. Then I lightly push the fingers back and forth across the edge, breaking up the outline. I use a quick, light movement so that I eliminate the solid line without removing too much of the pigment.

Another place I use this technique is wherever I find an unwanted flat area of color. In a painting with lots of loose strokes and interesting textures, having just one smooth area can destroy the spatial integrity of the whole image. To add texture, I lightly bounce my fingertips through that area. The result is a subtle texture with no substantial change in color or value.

Get rid of mistakes

One of the most valuable uses of blending or wiping out is to get rid of mistakes. This is obvious early in the painting, but further along it can be even more valuable.

After you have been painting for a while, your paper or board can become so saturated with pigment that it won't hold any more strokes. The tooth has been completely filled in. In this situation, the best solution can be to wipe off some of the pigment with a paper towel or a brush. This restores the original tooth of the paper, making it easy to work over the offending area with fresh strokes.

Accept the limitations of sandpaper

Earlier I mentioned that blending on sanded surfaces can be difficult, if not impossible. Because of the deep tooth of sanded surfaces, it holds pigment securely in place, making it almost impossible to blend the pigment from one place to another. Another problem is the effect a sanded surface can have on your blending tool. Paper towels will be ripped to shreds and fingertips will lose their top layer of skin.

Because I depend so much on blending techniques, I rarely paint on sanded surfaces. It might be possible to blend with a chamois or other piece of leather, but I have never tried it. Basically I suggest that if you are planning to blend, don't work on sanded surfaces.

The one commercially available sanded paper I have found that is good for blending is Colourfix from Art Spectrum. It has a very smooth surface that makes blending a pleasure. However, the tooth is shallow, so it won't hold as many layers of soft pastel as some of the rougher surfaces.

ART IN THE MAKING

BY USING A COMBINATION OF SOFT PASTELS AND TEXTURED PAPER, YOU'LL FIND YOU HAVE MANY POSSIBILITIES FOR BLENDING

At a concert of the choral group Chanticleer, I saw a baritone who had a wonderful look — dark hair, big mustache and a tuxedo with tails. For some reason, his appearance made me think of Colonial England, so I decided to pair him with an appropriate spouse — a regal-looking woman with a strapless gown, tiara and nose sticking up in the air.

1

Taking notes
I didn't have a sketchbook with me, so I made a simple drawing of him in my program.

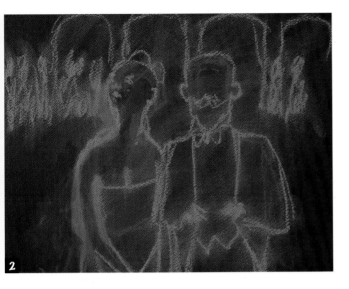

Sketching the figures

On a sheet of black Hahnemuhle paper, I began by sketching the man. I arbitrarily chose a reddish color for the sketch.

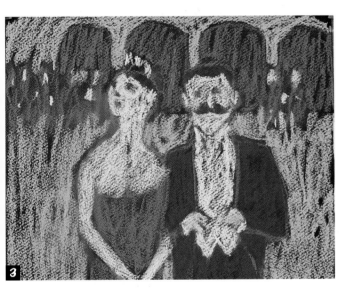

Adjusting the drawing

I wiped out the original drawing. With a lighter color to distinguish the lines from the first attempt, I refined both figures. I turned her head closer to his and changed her arm. I removed the red lines of her bent arm with a kneaded eraser. In keeping with my palatial theme, I drew arches in the background and added the suggestion of a crowd. I softened all the lines with my fingertips.

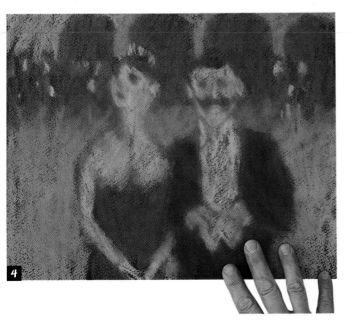

Establishing values

Before I began this step, I decided the pink lines were much too bright. I sprayed the painting with workable fixative to darken them. Then I began to block in the larger shapes. This early in the painting, I was primarily concerned with values, so I limited my palette to light and dark red-violets and blue-violets.

73

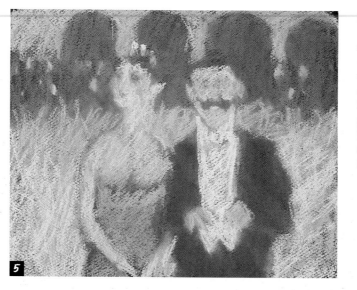

5

Loosening up

I wiped through all the strokes with my fingertips to keep the forms loose. I have found that if I lock in details or exact contours too early, it limits my creativity. I added greens in the background and in the figures to give richness and depth to the color. Then I blended again.

TIP 8

When I am doing a lot of blending on a piece, I periodically remove the drawing board from the easel and tap it on the floor to remove excess dust. Unless it is raining, I always do this outdoors. But first, I make sure my paper is securely clipped to the board so that it doesn't come flying off. This is especially important for artists who work with the painting flat or at an angle. You might want to wear a mask to reduce the risk of inhaling pastel dust during this process.

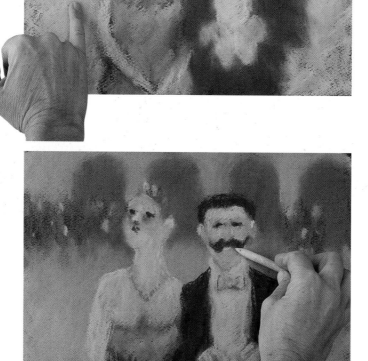

7

Repeating colors

I strengthened the color by cross-hatching the background with warm lavender, using a lighter value near the bottom to make it appear closer. I used the same color in his vest. I made a point of repeating colors throughout to unify the composition. For example, I used the same blue-violet for her dress and for shadowing the eyes. I added coral in several places to warm up the skin.

Blending with care

The image was becoming more definite now, so I was much more careful with my blending. I wanted to soften the colors without changing the shapes. To define small details, I used a drawing stump, which is a pencil-shaped cone of rolled paper.

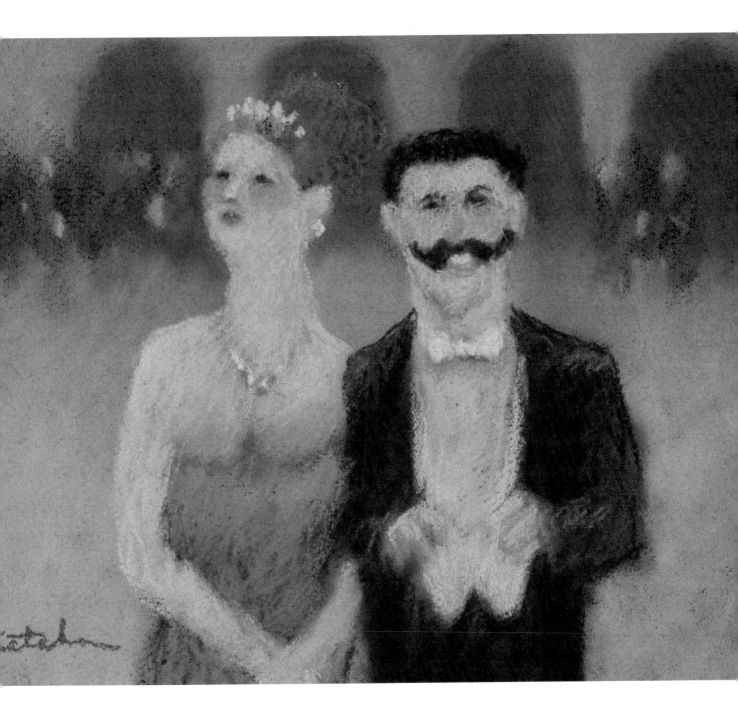

Refining the image

I was now refining colors, shapes and values. Remembering that yellow and purple are complements, I blended yellow ochre into the lavender background. This made the background color grayer and moved it behind the brighter colors of the figures. I added bright highlights to her jewelry to finish "For God and Country" (11 x 13" or 28 x 33cm)

Softening the light
Blending is a good technique for showing diffused light. Because I softened the edges of the window in the background, the light in "Floral Sonata" (19 x 25" or 48 x 64cm) seems softer. The effect is enhanced by the background colors gently blending into one another with no obvious strokes.

TIP 9

A great way to develop color harmony is to repeat colors throughout a painting. It is very easy to add accents of color by lifting pigment that is already on the painting and blending into other pigment elsewhere. For instance, let's say I am painting a woman in a red dress. I notice that her face is looking pale. I press a fingertip into the red of her dress. Some of the red pastel comes up on my finger. Then I blend that red pigment onto her cheek. I used this technique in the painting "Like Fine Wine" on page 99.

This is also a good way to give your shadows more life. Lift colors from other areas of the painting and press them onto the shadow area for subtle variations.

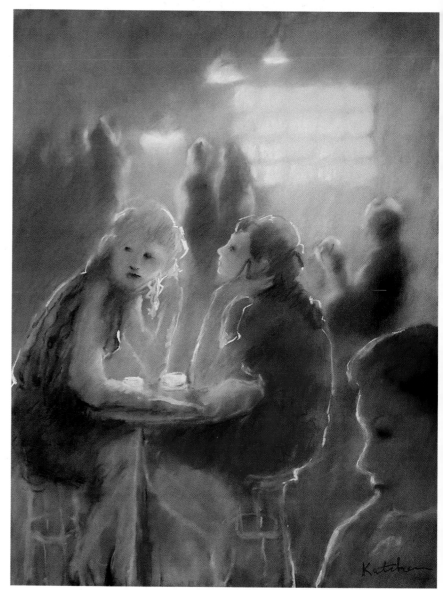

Adding depth and light
Creating atmosphere is easy to do with blending. In "Checking Out the Talent" (25 x 19" or 64 x 48cm), the blended color suggests spatial depth and, with a few bright accents, strong light coming through the rear windows.

Starting with a fluid design

The key to any landscape is the foundation of large shapes. With "Succulent Landscape" (18 x 26" or 46 x 66cm), I blended the first few layers of color to keep all of the edges soft. With no hard edges, I was readily able to adjust, simplify and even move shapes until I had the composition just right. Then I developed the surface color with many layers of unblended strokes.

REFRESHER COURSE
MAIN LEARNING POINTS IN THIS CHAPTER

1. The softer the pastels, the easier they are to blend.

2. Blending can help achieve a smooth, realistic look.

3. You can get a smooth, wash-like area of color by blending the area of strokes with a circular motion of your hand or a paper towel.

4. You can refine your initial drawing by smearing with a paper towel, then redrawing. Smearing the initial strokes across the entire paper also begins to build background color.

5. Blending is a way of mixing new colors.

6. You can use your fingertips to soften solid lines or create loose textures.

7. Painting over soft pastel with harder pastel sticks will cause the softer pastel strokes to blend together.

8. Blending is a great way to correct mistakes. Wipe the trouble area with a paper towel, then repaint.

9. Blending does not work well on most sanded surfaces.

USING MY 10-POINT CHECKLIST WILL HELP YOU IDENTIFY
THE BEST SUBJECTS FOR EVOCATIVE, HEARTFELT PAINTINGS.

What you need to know about choosing a subject

In the past, I spent a lot of time painting what somebody else thought was a good idea. What I love and always have loved to paint are people, not portraits, but people doing whatever they do in the world — talking, dancing, looking around, trying to impress each other. There were times, though, when I painted anything but people.

One dealer told me he could sell still lifes, so I painted still lifes. All of my friends were painting landscapes, so I painted landscapes. I painted some still lifes and landscapes that were actually pretty good, but my heart wasn't in it. Mostly I got bored and restless, stopping before the image reached its full potential. Eventually I learned that I have to paint what I love to paint. Only then am I producing the best images I can create. I am a happier painter and my collectors are more interested in buying my work.

Absolutely anything can be a good subject for a painting. That was the topic of my last book, *200 Great Painting Ideas for Artists*, which shows how even the strangest, most obscure, most unlikely idea will produce a wonderful image if it is something to which the artist can commit completely. Again, it comes down to painting what you like.

Find what interests you
There are many things that interest you enough to look at them or talk about them for a short time, but a great painting takes more commitment than that. Casual

observation isn't enough. You have to study the subject, live with it, know it well enough to break it down into its component parts and reassemble those parts on your painting surface.

Unfortunately in our fast, complicated lives today, we rarely pay that much attention to anything. We rarely know what images in our world fascinate us — who has time to stop and notice? Thus, the first step in finding the right subjects for your paintings is to stop and pay attention.

Once you start discovering those subjects that really appeal to you, stick with them. Explore them to the fullest. If you feel happy and challenged painting just one subject, continue to do so. If not, expand your horizons — no matter what anyone else tells you.

Many art dealers encourage artists to paint only one subject over and over again. This is especially true if that one subject is easy for the dealer to sell. But if I could paint only one subject, I would die of boredom. Even though I usually paint people, there are times when I see a wonderful flower arrangement, a still life or even a landscape that intrigues me enough to paint it. Painting different subjects keeps your eye and mind fresh.

Assess a possible painting subject
Occasionally, I see a subject that I think may have potential but I'm just not quite sure about it. If you struggle with this, too, here's a list of questions that will help you evaluate any potential subject.

Looking for great shapes
I always love painting dancers, but not all dance poses make good subjects. "Window Light" (39 x 27" or 99 x 69cm) works because it contains interesting abstract forms, dynamic gesture and dramatic lighting. When choosing painting subjects, never forget the abstract components.

1. Is this something I care about?

Every painting subject should relate to you and your life in some way. It can have a connection to your environment, your emotions or your fantasies, but it must reflect something about you.

2. Do I like the colors?

You should enjoy working with the colors of your subject. They don't have to be the colors you always use, but they should be attractive to you. Ask yourself: By using the colors in this subject, can I create interesting and harmonious color relationships?

3. Can I see a few main shapes to support the composition?

The foundation of any painting is the design or composition, which is built on the arrangement of abstract shapes. The most powerful compositions are structured on a few large shapes that divide up the total format. If you can see those basic shapes from the beginning, your composition will come easily.

4. Are there possibilities for dramatic lighting?

The element of a painting that creates the most visual drama is the arrangement of highlights and shadows. Finding subjects that give you an interesting relationship of light, dark and medium values is a major step toward paintings that arrest the viewer's eye.

5. Are there hidden nuances of color and form?

The paintings I most like to create and to buy are those that keep me looking. If I can see everything at first glance, I know this is not an image I will want to keep around. I love finding unpredictable bits of color, line and shading in my subject. That's what keeps me working on the painting long

Conveying a deeper message

The challenge with "Easter Bonnets" (22 x 30" or 56 x 76cm) was to take an absolutely trite subject — a mother and child — and make it interesting. I started with their body language. The mother is not only looking out of the painting, she is leaning away from her child. The baby is not doing any cute little baby things. She is just hanging there like a lump. Then I placed them behind a bouquet of very intense red and purple flowers, making it appear that the figures were almost an after-thought.

enough to make it a piece I'm proud of.

6. Does this subject reflect a mood or atmosphere?

A good painting is more than the sum of its parts. Besides good color, good composition and good draftsmanship, the best paintings convey something intangible — an emotion or mood that touches the viewer.

7. Will this be a challenge to my technical skills?

Every so often, it's nice to do a painting that's just plain easy, but without regular challenges an artist can go stale. I love a subject that pushes me beyond what I have accomplished in the past. There's an excitement in looking for solutions to new problems and a wonderful feeling of accomplishment when I have made those solutions work.

8. Is there a meaning here beyond the superficial appearance?

Not every painting has to make the viewer think, but those that do are pretty special. The painting continues to grow as the viewer grows in experience.

9. Will it sell?

This should never be the only question you ask about a subject, but it is a viable question, especially if you depend on your art sales for all or part of your living. Besides the practical considerations, selling a painting gives us tangible proof that our work is being appreciated. Also, I've found few things that dampen my enthusiasm for painting more than a stack of unsold paintings in my studio.

10. Is this something I care about?

It always comes back to your personal involvement with the subject. When I'm judging art shows, I can always tell how the artist felt about his or her subject. The artist takes extra care with the subjects that are important. Passion and intimacy are quite apparent. If the artist was bored or indifferent, that shows up, too.

Deal with the challenge of commissions

What about commissions? How can you express yourself when you are painting someone else's subject? Here are some ways I have learned to make commissioned paintings more enjoyable and more acceptable:

1. I make sure that the client is familiar with my painting style. I show any prospective collector a lot of examples of my work. I explain how I paint and point out what makes my style unique. I make it clear to them that any painting I do will not look photographic or classical. If a photographic likeness is what they want, I refer them to other artists or dealers.

2. I make sure that both the collector and I are as clear as possible about what is expected. Most people have trouble visualizing a painting, so I give them as many images to look at as possible. If it is a portrait, we look at many

Starting from abstraction

When choosing floral subjects, I look first at the abstract shapes — the shapes of individual flowers, but even more important, the shape of the whole group of flowers. It's the relationship of abstract shapes that gives a composition its punch. Look at the shape of this arrangement of flowers in "Chinese Dragon" (25 x 19" or 64 x 48cm). Notice the wonderful design it creates in the negative space.

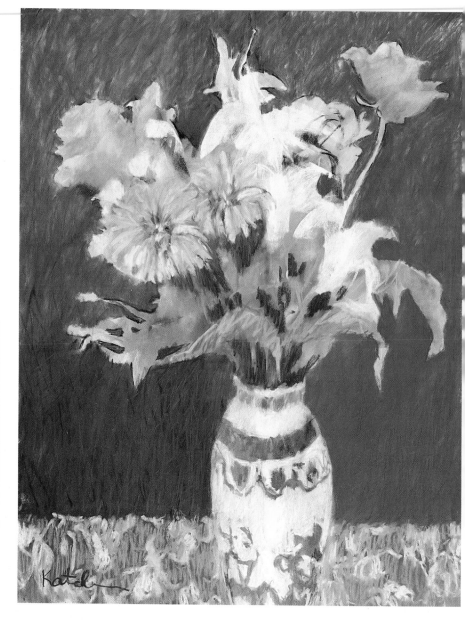

Whenever you look at a group of something, see it as one big shape. The most obvious example is a floral arrangement. Rather than seeing three daisies, six roses and two lilies, look at the overall shape of the total bunch of flowers. Use that shape as the foundation of your composition.

photos of the person. I ask the client what it is about each photo that best captures the subject. Communication is the key to a successful commission. It is the artist's responsibility to understand what the client wants.

3. Write up a simple agreement. Keep one copy for yourself and one for the client. This should include such crucial information as size, price, payment schedule, whether the price includes framing and deadline.

4. I get a substantial non-refundable deposit before I begin working on the project, usually ½ of the fee.

An alternative is to ask for ⅓ up front, ⅓ half-way through and ⅓ on completion. A deposit ensures that I will be paid for my time and it eliminates any client who is not serious about the project. Occasionally, I produce a small color study before they commit, but it's generally better to get the money first. Once money is exchanged, it puts the project on a more professional footing.

5. I invite the client to view the work in progress. I usually do at least one small color study before I begin the larger painting. Seeing their reaction to the color study

gives me a better sense of what they want. I also invite them into the studio periodically as I am working on the painting. I encourage them to make comments and suggestions. Some clients are reluctant to say anything negative about the work in progress, but I press them to be honest. I tell my clients that a commission is a painting that we create together. We must both be pleased with the finished product. I have learned that it is much better to find out things they don't like while I am still painting, rather than after the painting is finished. I am much freer to express myself in the painting process if I get regular feedback from the collector.

6. I never accept a commission to paint a subject that doesn't interest me. There must be something that engages me in the subject or I will hate doing it and that will show up in the work. Money is never enough of an incentive if I don't relate to the subject.

One final thought on commissions: There will be times when a collector or a dealer asks for a painting exactly like one I did before. I won't copy something I have already done, but I will create a similar painting if I still enjoy the subject. The crucial phrase is "enjoy the subject". I have known artists who found themselves painting a popular subject or theme over and over because there was such a demand for it. I am not usually one to turn down money, but there comes a point where you lose your enthusiasm and freshness about a particular subject. If you've reached that point, it is crucial to your career to turn down the "repeat" offers and find new subjects that engage and challenge you.

EXERCISE 1: DISCOVERING WHAT YOU WANT TO PAINT

Here are some exercises to help you find what most interests you. Keep a small notebook with you to make notes. You think you will remember, but write it down anyway for future reference.

1. Spend an afternoon in an art museum. As you walk through the museum, notice which paintings keep you looking at them longer than the others. Jot down what makes them interesting to you, especially the subject matter.

2. Visit art galleries. As you walk through the exhibits, make note of the paintings you wish you had painted. Notice style and technique. Note the subjects.

3. Look through art books and magazines. Which paintings hold your attention? Which make you wonder how the artist did them? Which look like something you would like to paint?

4. Keep a sketchbook. Add at least one drawing every day. There are many good reasons for keeping a sketchbook; one of the best is that it forces you to look at things, to see them at least well enough to make a quick sketch of them. After you have used up half the sketchbook, go back and look at your drawings. You should begin to see a pattern of subjects that interested you enough to draw them.

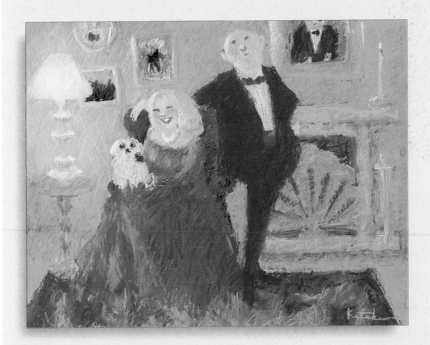

I love to paint people, but more than that, I love to imagine stories around my people. For instance, "The Object of My Affection" (18 x 24" or 46 x 61cm) started with my 83-year-old friend Sally who adores her dog Boo Fee II. When Sally came to model for me, she happened to bring along photos of her puppy, which inspired this tableau. I invented an appropriate man for the scene.

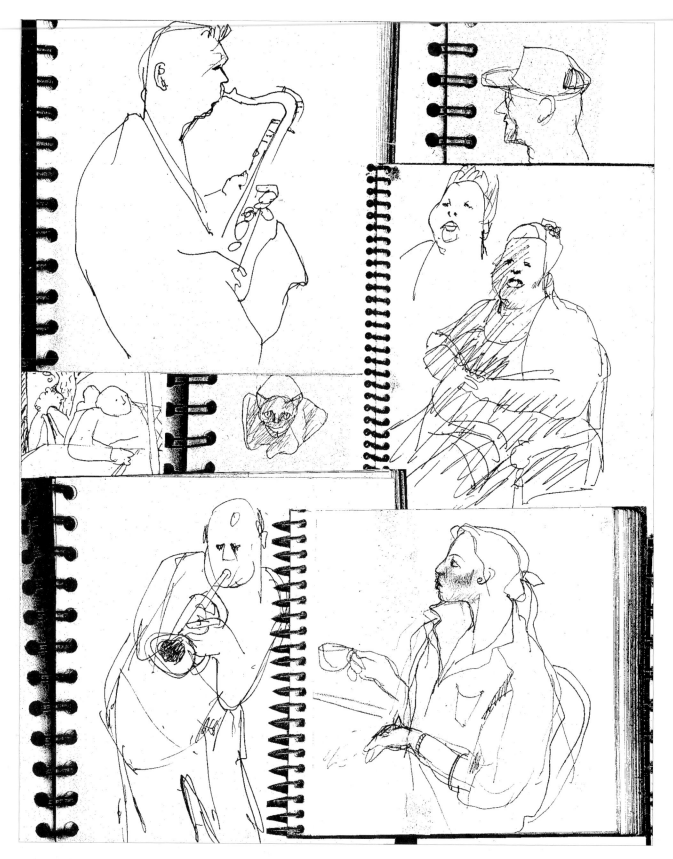

Recording life in a sketchbook

I strongly urge you to keep a sketchbook. The rewards are tremendous. Besides improving your drawing skills, the sketchbook serves as a great reference for possible subjects. I record ideas for future paintings, as well as details of costume, architecture, anatomy and expression in my sketchbook. At first, it might take some discipline to use your sketchbook regularly. Commit to making one drawing every day or at least five a week. They don't have to be refined or elaborate. Any marks you make in your sketchbook will contribute to your growth as an artist.

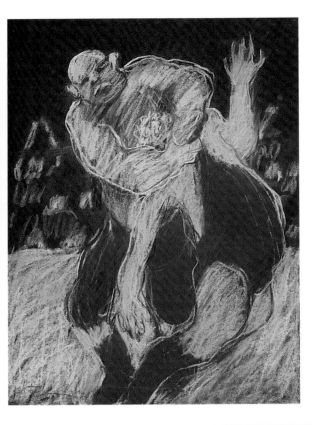

Investigating new subjects

Don't be afraid to try something different. Early in my career, a collector came to me and asked if I would be willing to paint some All Star Wrestlers. Mostly he wanted a painting of the young Hulk Hogan in action, so he offered to take me to a match at our local auditorium. I didn't know anything about wrestling, but how could I turn down a chance to discover something new? We sat in the fourth row and I completed a pile of sketches, focusing on movement, gesture and expression. Later I completed several large pastel paintings, including "Baron Von Raschke vs Dr. 'D' Schults" (25 x 19" or 64 x 48cm), from those sketches. The collector was delighted.

Adopting a subject

Sometimes I have to work with someone else's subject idea, so the challenge is to make it my own. In this case, I was commissioned to paint a scene of the local farmers' market for a television station. I used their video footage as well as my own on-site sketches to create this color study for "Vine Ripe" (18 x 24" or 46 x 61cm).

Choosing the best models

I used personal friends for all of these paintings —
"The Belle of Stuttgart, Arkansas" (31 x 23" or 79 x 58cm),
"Of Course, I Come Here Often" (31 x 25" or 78 x 64cm)
and "Another Look at Patricia" (16 x 13" or 41 x 33cm).
Besides having beautiful physical features, these women
have a far more important quality — great personalities.
I cannot over-emphasize the importance of choosing
models whose energy will contribute to your painting.
I have taught many classes and workshops where the
model was bored. Almost without exception, my students
painted boring paintings. An enthusiastic model, however,
will provide you with more interesting expressions, more
interesting poses and more interesting costumes, which
leads to better paintings.

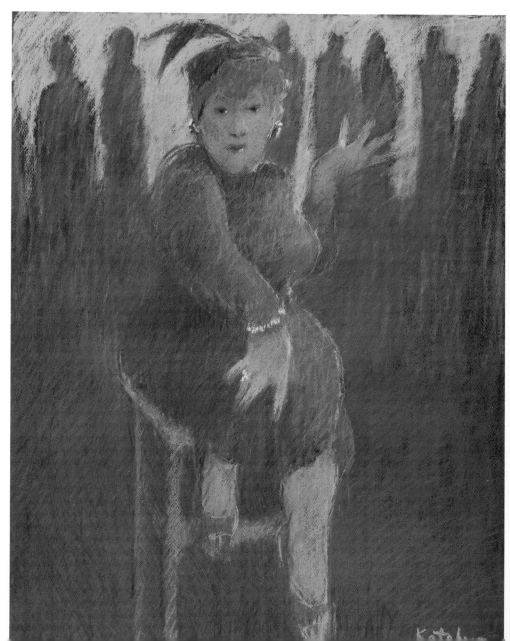

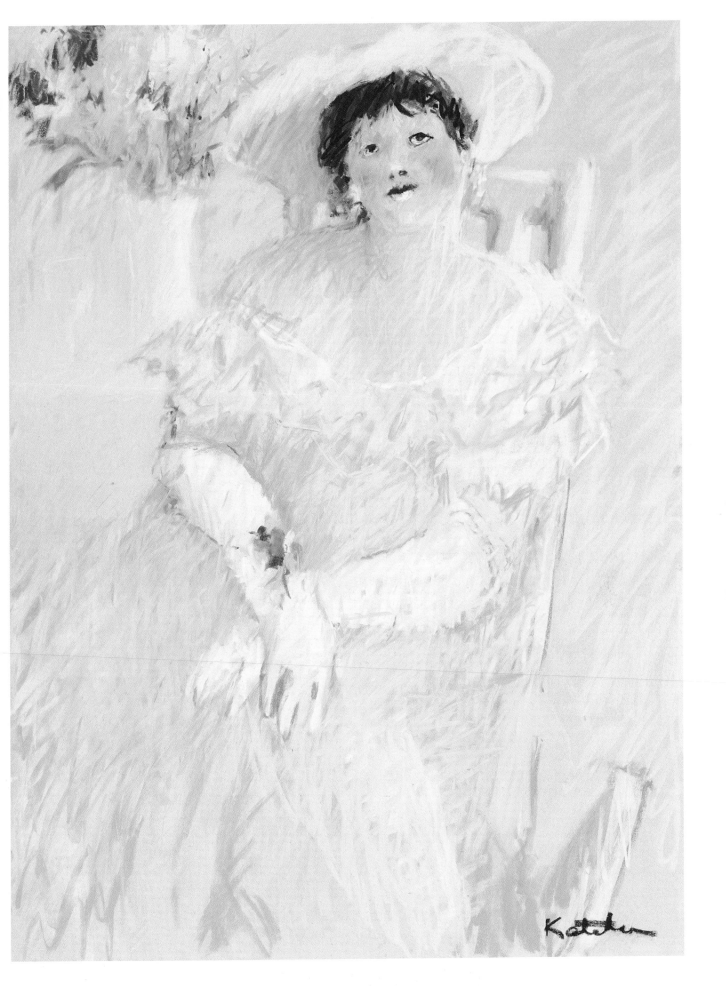

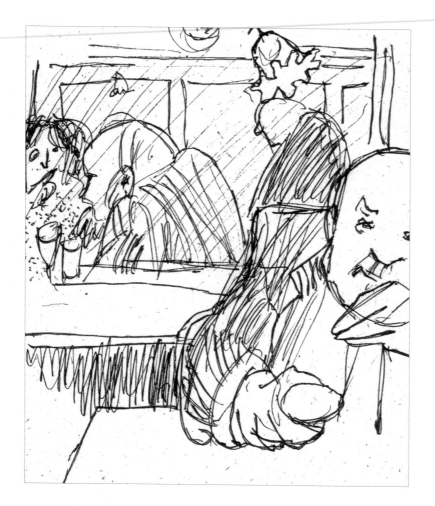

Working from life
My New Orleans friend Bill Bennett has been lunching at Galatoir's every Friday for years. He invited me to join him and his friends to commemorate the occurrence. I think I shot some photos, but I took "First Martini at Galatoir's" (19 x 25" or 48 x 64cm) directly from my on-the-spot sketches. What made this painting more successful than a traditional portrait of people sitting at a table was the unusual point of view. I could focus on Bill's impish expression in the foreground and add ambience with the reflections in the mirror.

If a painting is being commissioned by a couple, make sure that both partners see the painting in progress. If they can't both get to your studio, shoot photos of the work-in-progress and ask both partners for comments. I have learned the hard way that one spouse is not always going to like what the other approves.

88

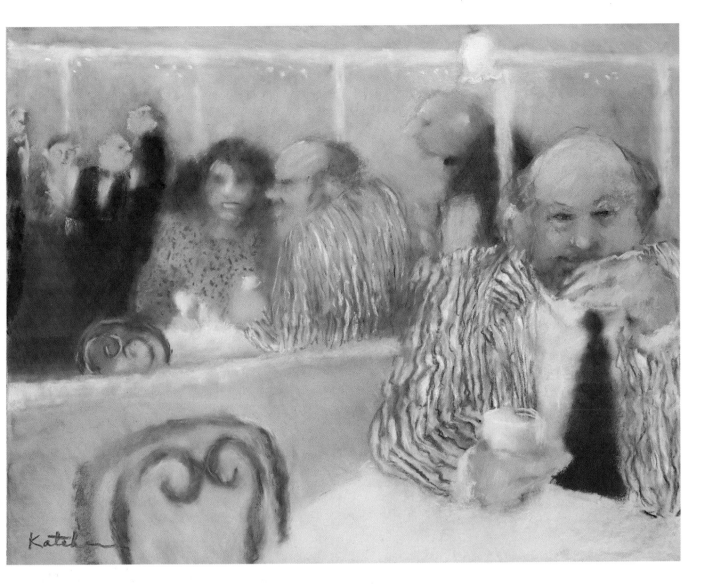

Building on great shapes
I was drawn to the early morning scene in "Emerging From the Mist" (22 x 31" or 56 x 79cm) by the interesting pattern of shapes. Gradually the morning mist lifted, revealing an unexpected richness of color in the foreground.

WHEN YOU FIND A SUBJECT YOU REALLY LIKE, DON'T BE AFRAID TO U:

My first study of a friend who is a poet turned out well, but I felt I could make it into a more complete subject. I looked at his profile and thought about how self-absorbed poets have to be to develop their art. That led me to imagining a relationship between two people who are both self-absorbed.

Finding a great subject
I was pleased with "Echo of a Poet" (25 x 19" or 64 x 48cm), a study of my friend Chuck Dodson. It became the springboard to another work.

TIP 12

When selecting a human subject, there are many more things to consider than how pretty the model is. One of my pet peeves is artists, especially male artists, who select their models on that basis alone. How many figure studies have I seen of pretty girls with no more life or expression than a bowl of wax fruit? Models are, first of all, people — people with thoughts and feelings. When you select a model, consider gesture, expression, personality and mood, as well as appearance. Those things will have a large impact on your painting.

Tapping other sources
I looked around at my women friends for models and settled on my friend Kay Polk, who has a great profile. Unfortunately, she lives in another town, so I only had time for this quick sketch when she stopped by for a visit.

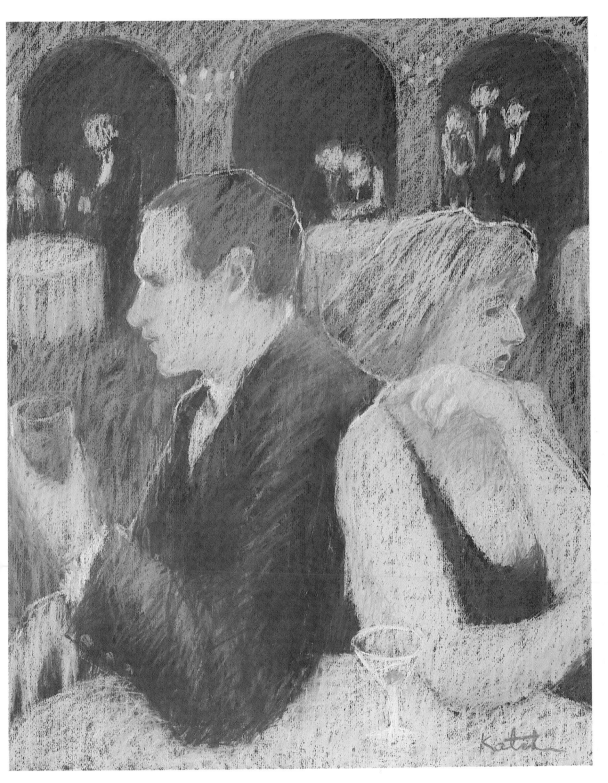

Putting it together

In "So Much in Common" (31 x 25" or 79 x 64cm), I put the two figures together, adding some drinks and a restaurant setting. Chuck and Kay have never actually met, but in this painting I was able to make their imaginary relationship look quite convincing.

Finding the right ingredients

When choosing a landscape, it's important to look for the required elements of good design. Find a scene that can be divided into a few interesting shapes, and look for strong value contrast and at least one focal point. For example, the focal point in "The Swimming Hole" (19 x 25" or 48 x 64cm) is provided by the water culvert. The light shining through it makes a dramatic contrast against the deep shadows. Also, its geometric shape contrasts with the irregular, natural shapes surrounding it.

TIP 13

When picking a location for a landscape, there are several painting considerations to keep in mind.

1. **Pick a scene that has an obvious focal point, something that immediately draws your eye.**
2. **Limit the scene to one rectangular shape of scenery. Carry a small rectangular mat with you. By looking through the window of the mat, you can get a sense of how the scene will work as a painting.**
3. **Look for a scene that is comprised of a few large abstract shapes. Don't be distracted by the details. The painting will only be as strong as its underlying structure.**

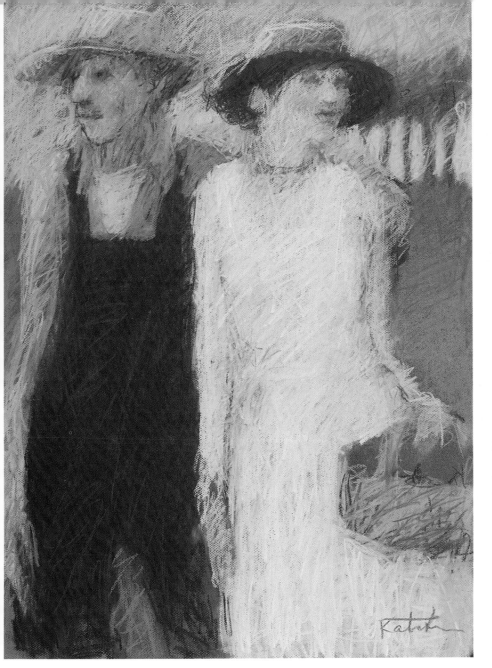

Leaving it to the viewers

I love to paint subjects that tell a story, especially when the story can be interpreted in different ways. In "A Fine Harvest" (29 x 21" or 74 x 53cm), for example, the relationship is somewhat ambiguous. Are they a united, happy couple, proud of their accomplishments? Or does the fact that they look away from each other suggest a barrier in their relationship? That's for you to decide.

REFRESHER COURSE
MAIN LEARNING POINTS IN THIS CHAPTER

1. Anything can be a good subject for a painting. Even "boring" subjects will work if they are painted in an interesting way.

2. Always choose subjects that interest you.

3. Painting a variety of subjects keeps your eye and mind fresh.

4. What makes a good subject?
 - Personal interest
 - Attractive color
 - Good design of abstract shapes
 - Dramatic lighting
 - Nuances of color and form
 - Mood or atmosphere
 - Technical challenge
 - Deeper meaning
 - Salability
 - Passion and intimacy

5. It is possible to express your own vision in a commissioned painting. Some steps to take:
 - Familiarize the client with your style before you begin
 - Be absolutely clear on what the client expects
 - Prepare a written agreement
 - Get a substantial deposit
 - Have the client review the work in progress
 - Never accept a commission unless the subject interests you

THERE ARE PLENTY OF "RIGHT" WAYS TO GET STARTED ON A NEW PASTEL PAINTING. YOUR JOB IS TO DETERMINE WHICH ARE BEST FOR YOU.

What you need to know about beginning a painting

Creating a painting is something like building a house. There are some ways to start the project that seem more sensible than others —- putting up the walls first, for instance, before you build the roof. You add many different elements to the walls, one by one, until you have a structure that is solid, balanced and pleasing to the eye — at least that is what you hope. The reality might leave something to be desired.

It's the same with creating a painting. Some methods allow more ease and grace in their execution. However, given the inventiveness and the quirkiness of artists, I can imagine some artist "building the roof first" and making it work quite well. You just have to find what works for you.

Break "the rules"

How you begin a pastel painting will certainly affect whatever comes later, but I don't believe there is one right way to begin. I am always dismayed at instructors who teach "the right way" to work with pastels. Saying there is a right way implies that everything else is wrong. I believe there is no right or wrong with pastel, only what works and what doesn't work to achieve the result you want.

In my workshops, students often tell me "rules" they have learned from previous instructors. The most common claim is that you have to start with hard pastels and work up to soft pastels, otherwise the pigment won't stick. Another rule is: Never apply dark colors over light because the colors are deadened.

Sometimes these things are true, but sometimes they're not. To be quite honest, there is no rule I have heard about pastel that is always true. Whenever someone gives you rules, they limit your range of possibilities. With some painting media like oils or watercolors, rules can save you from disaster, but with pastel painting rules only cut down your range of expression.

For me, the better way to look at painting is from the standpoint of problem solving, so in this book, I am not giving you any rules. I am offering suggestions to help you get more quickly and easily to a desired result, as well as exercises to lead you into a more imaginative way of working. Following are some of the more common methods I've seen for constructing a pastel painting.

Try the coloring book approach

The most common way of painting is what I call "the coloring book approach". First, you draw all the outlines, then you fill in the shapes with color. I don't know if this is a natural way of painting or if we do it just because we were exposed to coloring books as children. I use this approach myself when I am most concerned about accurate representation, such as with a portrait.

This approach depends on knowing from the beginning how you want the painting to look. So I recommend

Making a false start
I should have begun "Sycamores on Guard" (26 x 18" or 66 x 46cm) with a mosaic approach, focusing on the dramatic pattern of large positive and negative shapes in the trees and sky. Instead, I tried to include all of the branches, and the image got much too complicated too soon. I had to spray with fixative and begin again, this time concentrating on the rhythmic shape of the tree trunk.

beginning with preliminary studies — both black-and-white and color — to design the composition, values and colors. (Some artists work directly from photographs, copying the photographic image as closely as they can. For me personally, that begins to feel too much like work and not enough like art. However, I have seen other artists create wonderful images that way. I think in particular of large close-ups of flowers where the abstract shapes of light and color take on a dramatic presence in the large scale.)

With this approach, it is important to consider how the first lines you draw will affect your finished painting. First, what color should you use for the initial sketch? Heavy, black outlines are usually the easiest to see, thus giving you a clear guide for the placement of future colors. However, it is difficult to cover or blend black into your later painting. Unless you

are working in an Expressionistic style where the finished work incorporates somber colors and heavy outlines, I suggest avoiding black for your initial sketch. White is also difficult because it can dull your later colors when they blend with the white. Your best choice is a middle value of some color that will harmonize with the rest of your palette.

If you want a natural look to your finished image, try the classical method of using earth colors such as burnt umber for your initial drawing. For more interesting, but less predictable color, try a middle value of some unexpected hue — turquoise, red-violet or gold. By leaving bits of the initial drawing uncovered, you will automatically get interesting accents of color in your finished painting.

Harder pastels give you a preliminary sketch that is easier to cover, but whether you are working with harder or softer

Breaking up outlines
Outlines can be a problem because they tend to flatten out shapes. In this glass vase in "Sunshine on a Rainy Day" (23 x 31" or 58 x 79cm), for instance, leaving a solid outline would have destroyed the illusion of three-dimensional form. I softened and broke up the outline by hatching through it with lines of the lighter background colors.

pastels, the color of your initial outlines will alter your later colors as they blend together. To minimize that blending, you can spray your finished sketch with workable fixative. Then you can paint over those first lines, eliminating them completely if you want, with no sign of their ever having been there.

The other concern about outlines is that they tend to flatten any shape they surround. I have seen so many still lifes submitted to exhibits where the oranges and apples are beautifully modeled, bright highlights blending into shadowed areas into reflected light. The fruit would look absolutely three-dimensional, except for the solid outline around them. The result is fruit that looks like flat cut-outs. You don't have to eliminate all the outlines in your paintings, but your work will look more realistic if you use outlines sparingly. Break them up. Let them blend into shapes they surround.

Of course, completing a wonderful contour drawing is only the first half of this painting technique. The next step is adding color. The challenge is filling the outlines without making your painting look like, well, a page out of a coloring book.

How hard or soft your pastels are will affect how you proceed. If you completed your initial sketch with harder pastels, you can use either harder or softer pastels next. If you want to build up your colors more slowly with several layers of strokes, harder pastels throughout will give you more control.

If you began with very soft pastels, you might have some trouble covering those strokes with harder pastels. If you plan to put down a single layer of strokes, softer sticks may work better. They cover the surface quicker and with less pressure. You can also use a combination — laying in the basic colors with harder pastels and then intensifying some or all of the colors with softer sticks.

Whatever kind of pastels you use, here are some tips to make the finished painting look more polished:

• Limit your palette and repeat every color at least once within the painting. This will give you greater color harmony.

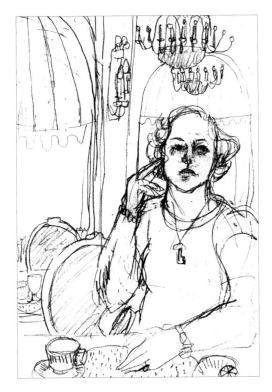

Sketching on-the-spot
Because precise drawing is so important with the coloring book approach, I suggest taking the time to do preliminary sketches like this one because it helps you become familiar with your subject before you begin the painting. This scene took place during a brief trip to Galveston. I didn't have a camera with me and knew I wouldn't be able to go back later to fill in missing details. So I took the time to do a very complete sketch and I made written notes of colors and details, which helped me create "Brunch at the Hotel Galvez" (39 x 27" or 99 x 69cm).

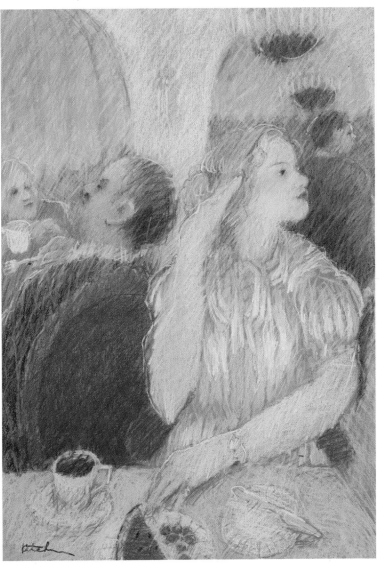

IF YOU'VE GOT A CLEAR IDEA OF HOW YOU WANT YOUR PAINTING TO LOOK, TRY STARTING WITH THE COLORING BOOK APPROACH

This painting started with an idea. I had just painted several scenes with older men and younger women. I thought it would be fun to turn the tables with a painting of an older woman surrounded by younger men.

Starting by outlining
I decided to use a quick version of the coloring book approach — basically, drawing the outlines and filling in the colors. For my initial drawing, I used hard Holbein pastels on black Colourfix paper by Art Spectrum. I paid special attention to the postures and general body language, which is where I usually tell the story in my paintings.

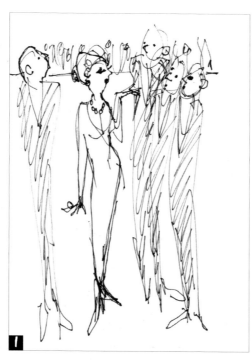

Working out the design
In this sketch, I worked out the basic image and composition.

Switching to softer sticks
I blocked in the colors with Unison pastels, which are softer than the Holbeins because I planned to blend them. I chose greens, violets and Indian red.

Modifying edges
Lightly moving my fingertips across the contours, I eliminated all of the edges. Colourfix is a wonderful paper for blending because the pigment moves easily on the surface.

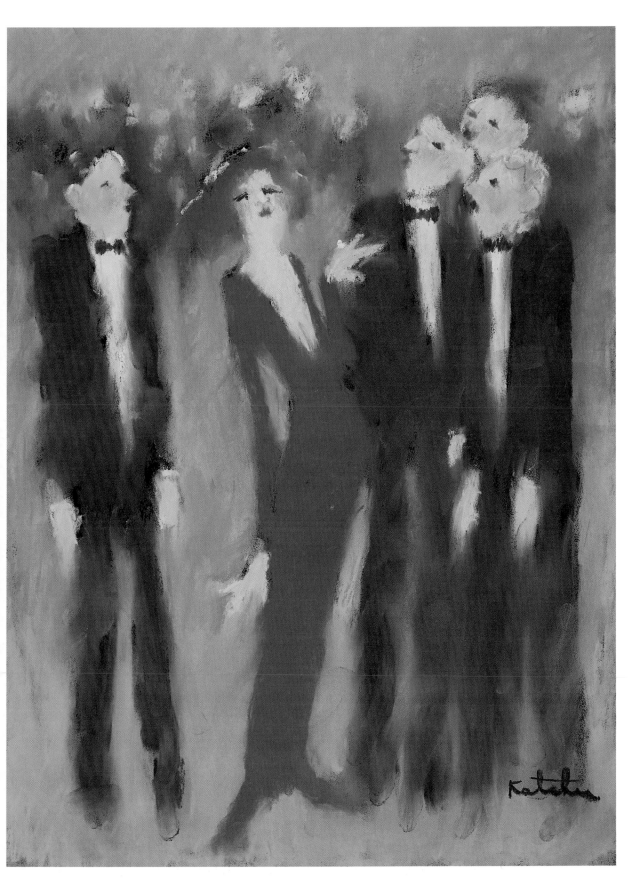

Filling in with color

I warmed up the foreground with a warm green ochre and darkened the background with a dark green, then blended.
With a fingertip, I lifted some red color from the dress and applied it to the cheeks. Then I went back to the Holbein
pastels for my final details. The smaller sticks of harder pastel lend themselves to precise work, so I used them to add
hair, facial features and a few other final details to "Like Fine Wine" (17 x 13" or 43 x 33cm).

- Remember that each stroke has value as well as color. Be constantly aware of how light and dark the strokes are.
- Think of each small piece of the image as part of a larger section. Remember that each tree and each flower has to relate to what is around it.
- Soften at least some of your edges. You can blend by rubbing the colors together with a fingertip, a drawing stump or a stick of harder pastel.

Try the old master approach

As its name implies, this method of painting is taken from the master oil painters. In their classical procedure, they fully rendered the subject first in burnt sienna, burnt umber or some other earth tone. After they were fully satisfied that they had captured the basic composition of form and value structure, they began to add "local color". Local color is the color that appears to the eye.

Generally, the first strokes of local color were applied thin enough so that the values continued to show through. Only toward the end of the painting did they apply accent strokes of strong, opaque color.

This technique can be used exactly the same way with pastels. After you complete a monochromatic rendering of the subject, you can add additional color in thin layers. Harder pastels work best for this method because they are easier to work over and won't obliterate what is beneath them, unless you press them into the paper with great force. The monochromatic underpainting not only gives you a guide to the values, but that base color blends with all your later colors, giving your painting greater color harmony.

You can use an initial color other than brown. Sometimes, I'll do the initial rendering in violet, burgundy, green or blue, knowing that the first color will tone all the later strokes. This can be an effective way of developing a particular mood from the beginning. However, I have found that black doesn't work well for the underpainting. It overpowers the subsequent colors, making them appear colder, less brilliant and sometimes just dirty.

It is also possible to use the same technique with softer pastels. The biggest problem is that soft pastels tend to totally

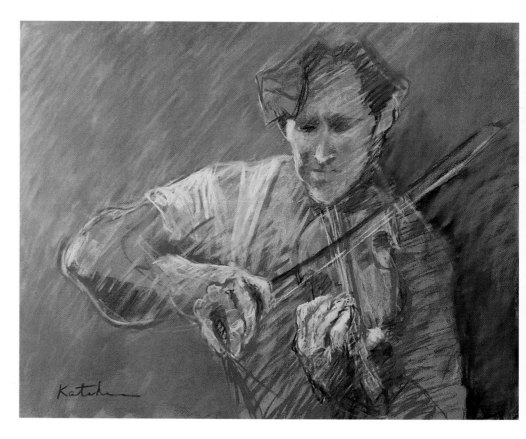

Painting like the masters
For "First Violin" (19 x 25" or 48 x 64cm), I chose the old master approach, rendering the whole image first with just one color to capture the contours and values. I used a deep red to lay in the subject, then stayed with the same family of colors to fully develop the values. At that point I could have continued, adding thin layers of local color until the image was solid. However, I liked the loose, choppy feel of the painting as it was. It seemed to reflect the music he was playing, so I stopped.

fill the surface texture, but you can minimize this effect in a few different ways. One is by blending or wiping out. After I complete my initial monochromatic drawing in very soft pastels, I will often wipe over the entire surface lightly with a paper towel. This smears the original drawing, but generally leaves a strong enough ghost image to work over. Wiping the pigment over the entire sheet of paper gives me a thin layer of color that becomes the basis for my background. It also thins the heavier strokes of soft pastel enough for the tooth of the paper to hold subsequent strokes of color.

The other method is using my old standby — workable fixative. After I complete my monochromatic painting, I can spray it with workable fixative, thus giving myself a fresh tooth to paint on. Now I can proceed with either harder or softer pastels. With subsequent layers of soft pastel, I either apply the color in very light strokes or lightly wipe with paper towels. If the pigment fills up the tooth of the paper, I spray again.

Try the mosaic approach

The "mosaic approach" is a great technique for developing a painting with a cohesive composition. However, it requires an ability to visualize your subject in terms of simple, abstract shapes of color and value. Whether you are looking at a landscape, a still life or a figure, you must ignore your knowledge of what the subject is and simply see the squares, circles, triangles and other regular and irregular shapes that compose the image.

You start by dividing your total subject into just a few large shapes, no more than three or four. Using a very small selection of pastels, lay in those shapes. Do not think at all about details at this point. The object is to define the major forms with just a suggestion of their general color and value. For instance, in a landscape you might start with large shapes for sky, mountains, clump of trees and foreground. Color, at this point, is primarily to help you differentiate the

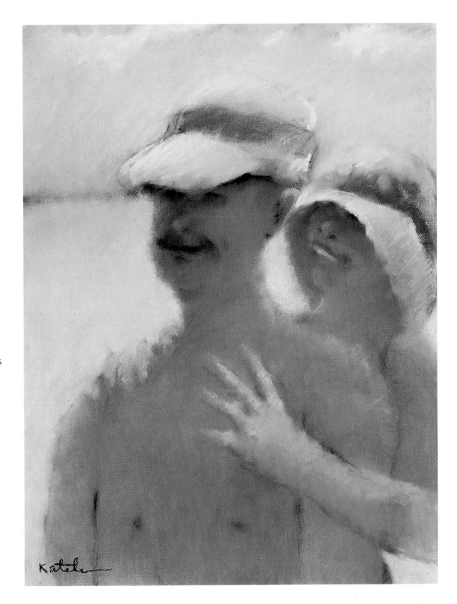

Learning to see big shapes
When painting human subjects, artists sometimes forget about the abstract shapes, which is why the mosaic approach can be so helpful. In "Honeymooners" (25 x 19" or 64 x 48cm), I viewed the two figures as one large shape. Notice how my negative space becomes one overall, interesting shape, providing a solid structure.

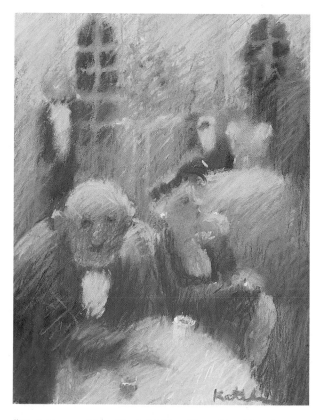

"Club Scene, Blue Study" (12 x 9" or 31 x 23cm)

Whether you're using the coloring book approach, the old master approach or the mosaic approach, preliminary studies allow you to try out colors, designs and characters so that you can finish your larger paintings with more confidence. Color studies are also very valuable when working on a commission. Having a visual presentation gives collectors a point of departure for analyzing what they want and what they don't want. It saves a lot of confusion and frustration along the way. I also find that the small color studies sell well to individuals who don't have a lot of wall space or a large budget.

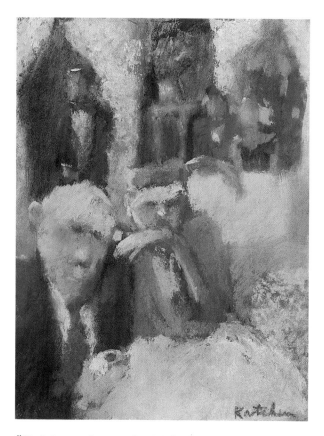

"Club Scene, Orange Study" (12 x 9" or 31 x 23cm)

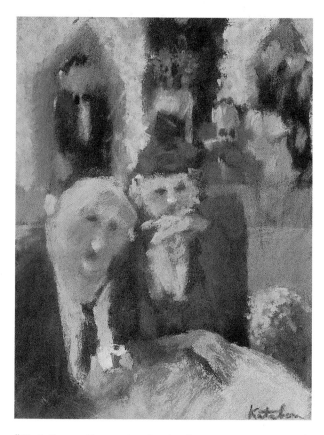

"Club Scene, Turquoise Study" (12 x 9" or 31 x 23cm)

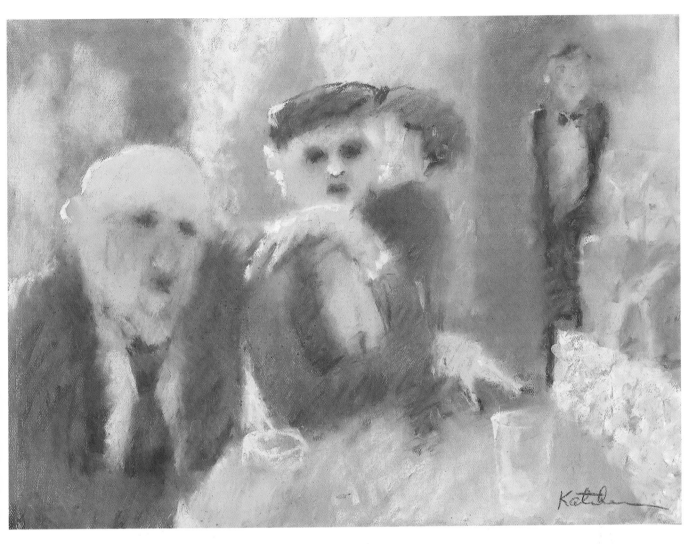

Following a new direction
After all of the vertical studies, I decided I would rather use a horizontal format. I incorporated many of the elements from the studies to arrive at "Club Scene" (21 x 29" or 53 x 74cm), but I also added some new ideas. I never simply enlarge a color study. For me, just copying another picture has little challenge. I like each new image to be an adventure in itself.

EXERCISE 2: FLATTENING AN IMAGE

On one sheet of paper, paint two separate oranges. Model them so that they each look as three-dimensional as you can make them. Be sure that you eliminate any hard outlines. When they are finished, draw a dark, solid outline around just one of them. Look at how much flatter the outlined sphere looks than the one without an outline. Now that you know what outlining does to the volume and depth in an object, you can avoid this technique or use it deliberately, as you wish.

shapes. Keep the initial layer of color thin enough so that you can work over it.

Now divide those few large shapes into the next smaller shapes. The sky becomes sky plus cloud shapes. The clump of trees becomes several separate tree shapes. Continue to look at abstract forms. The temptation with most artists is to concentrate on details too early. With this type of painting, you don't want to focus on a single small detail until you are almost completely finished with the painting.

As you divide your composition into smaller shapes, you can increase your palette with just enough new colors to differentiate the shapes. All you want to establish is the general color and value of each shape. Don't get distracted by nuances of color and value — those are just more details. Your colors will automatically get richer and more interesting as you go along because whenever you subdivide a shape, you add new colors on top of the old.

Again, divide your larger shapes into smaller shapes. Each tree becomes one shape for the trunk and one for the foliage, or you can think of it as one shape for the sunlit side of the tree and one shape for the shadowed side.

Eventually you will get to the smallest shapes, such as individual leaves, flowers, shadows and highlights. By the time you delineate these small details, you will have created a solid foundation to support them.

Try the scavenger hunt approach

When I'm in too big of a hurry to stop and plan my painting ahead of time, I use "the scavenger hunt approach". Of course, because I have no idea where I'm headed with the piece, it ends up

Hunting in the landscape
"Shadow on a Fence" (19 x 25" or 48 x 64cm) began with the brightly colored tree. Working on location, I painted that first. Then I added just enough elements from the background to keep my negative space from looking empty.

Katelinn

taking twice as long to finish it.

I begin with my focal point. If it's a figure painting, I might start with the gesture of the body — whatever it is about the subject that I find most intriguing. I place that part of the subject into the painting and then I add, piece by piece, the other parts of the image as I think of them. If I start with the face, then I'll add the rest of the head, the body, some furniture, the floor, other figures, a background — whatever seems called for to complete the painting.

This is the most exciting way to paint in the same way that hitchhiking across Africa with no map and little money is exciting. You will probably get to someplace interesting, but not without a lot of frustration and anxiety along the way.

As much as it seems that the best way to express yourself would be total spontaneity, it's actually the opposite. When you don't plan and organize ahead, you are forced to spend the whole trip coping with one disaster after another. The composition doesn't balance. The colors don't harmonize. The darkest values are where the sun should be shining.

It's possible to repair any mistake in a pastel painting, but why spend all of your time fixing blunders? With just a small amount of planning, your painting experience can be a joyous adventure.

Combine approaches

Some artists find one approach that works for them and stick with it through every painting. Others, myself included, combine methods or move back and forth between different methods. I suggest you try many methods, then choose whatever helps you express your own vision in the freest and strongest way.

Just remember, the first strokes you lay down will affect every other stroke that goes onto the painting. It is invaluable to take time to think about where you are going with a painting and plan how you will get there before you make a single stroke. You might end up deviating widely from your initial plan as you progress, but at least you begin with a solid foundation.

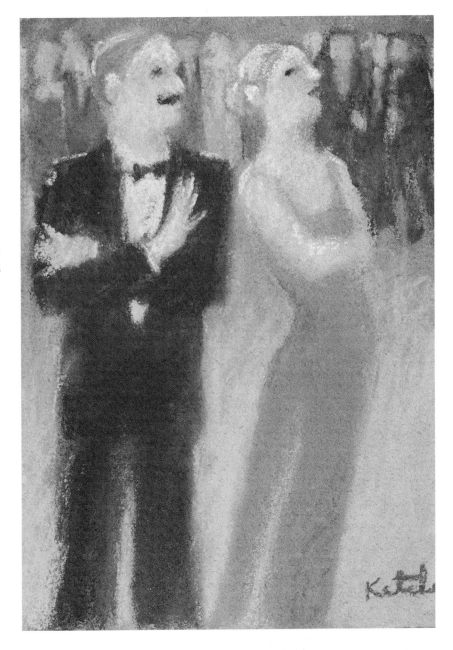

Beginning with a pose
I developed "When Pigs Fly" (12 x 9" or 31 x 23cm) with the scavenger hunt approach, beginning with the woman, particularly with her posture. To counteract the aggressive curve of her pose, I added a man firmly planted in the ground. I decided they needed an audience for their personal drama, so I added a crowd. Finally, I created a sense of space by painting the background with warmer, brighter color at the front (the bottom) and cooler, darker color at the back (the top). Since the figures at the back were only minor players in this drama — subordinate to the focal point that started this "scavenger hunt" — I kept them as simple abstract strokes of color.

BUILDING A BASIC ARRANGEMENT OF SHAPES THROUGH THE MOSAIC APPROACH WILL GUARANTEE A STRONG COMPOSITIONAL FOUNDATION FOR YOUR PAINTINGS

This approach to painting requires the ability to see the abstract shapes of a subject. The composition is built by gradually sub-dividing those main shapes into smaller and smaller shapes.

Seeing the big shapes
The first step was seeing the subject in terms of the three largest shapes — the wall, the floor and the figure.

Subdividing into smaller shapes
I broke it down into the next smaller shapes — windows, window reflections and his head and chest.

EXERCISE 3: DESIGNING COMPOSITIONS

For artists who are not used to pre-planning their compositions, it is invaluable to render subjects as just a few abstract shapes. This is an exercise to help you reduce subjects to figure and ground.

Choose a pot or vase with an interesting shape. Set that vase on a table. Now pick three sticks of pastel. Use one color to draw the shape of the vase. Use another color to draw the shape of the table. Use the third color to draw the shape or shapes of the background.

Now change your position. Move closer to the subject or further away. Move to the right or to the left. From where you are now, the vase should appear to be larger or smaller or to the right or left of the rest of the composition. Once again draw the three main shapes and fill them in with your three colors.

Repeat the exercise until you have five completely different compositions for the same few objects.

Building on the foundation

The final stage of the painting process was defining the smallest shapes and details. Even in a simple character study like "Harry's Fur Coat" (39 x 27" or 99 x 69cm), it is essential to develop the design of the entire painting. By organizing the shapes from the beginning, I wound up with a foundation that supports the central figure rather than detracting from it.

TiP 14

Details can be a terrible distraction when you are laying out the structure of your composition, no matter which starting approach you're using. So often in workshops, I see students start to put in the eyelashes before they have determined the shape of the face. How can you know where to put the eyelashes or any other detail until the bigger shapes are in place? Concentrate only on the large shapes first.

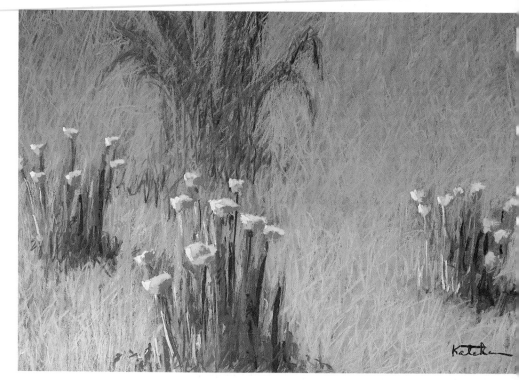

Branching out from the center
I used the scavenger hunt approach to create "End of the Rainbow" (18 x 26" or 46 x 66cm). I started with the central bunch of flowers and gradually added the other elements. In the end, I used pure colors in the focal point flowers to give them extra punch against the grayed-out complements of the background.

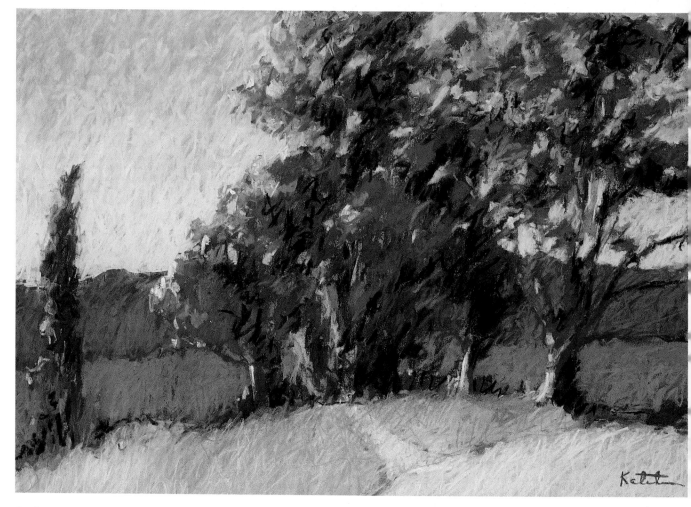

Saving details for the end
I always start a landscape such as "Water Music" (18 x 26" or 46 x 66cm) by laying out the largest shapes and values. Once the basic composition is set, I can take time to look carefully at the scene around me and pick the most important details to complete the painting.

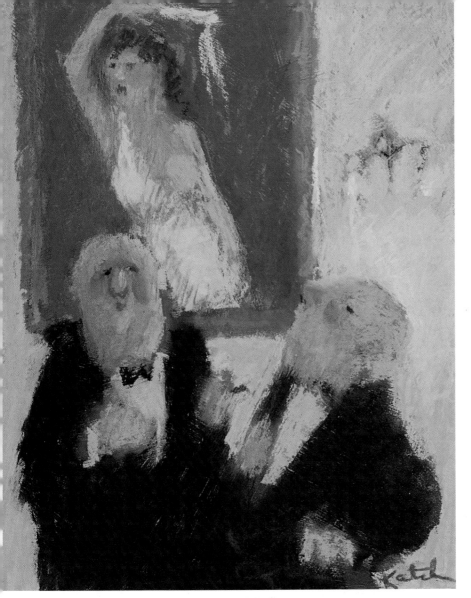

Painting a painting

A painting I saw in a bar in New Mexico inspired "Venus Comes to the Men's Club" (12 x 9" or 31 x 23cm). It was a picture of a romantic gypsy girl with one breast exposed, framed in an ornate, carved gold molding. I looked at the painting and thought, "This belongs in a men's club with a couple of old geezers in front of it". I began my composition by recreating the painting as my focal point. Then I added the two old men and a simple background with wall sconces for atmosphere.

REFRESHER COURSE
MAIN LEARNING POINTS IN THIS CHAPTER

There are no hard-and-fast rules for working with pastels.

There are several different approaches to constructing a pastel painting. Here are four:

1. The Coloring Book Approach
Start with a precise contour drawing of the subject, then fill in the colors. With this approach, preliminary studies are very useful. Outlines should be covered or broken up so that they don't flatten out shapes in the finished painting.

Some suggestions for successful development of color in the image:
- Limit your palette and repeat those colors throughout the painting
- Remember value as well as color
- Think of large sections of color
- Soften at least some edges

2. The Old Master Approach
Begin by rendering the subject with only one color, perhaps brown or an earth color. Develop shading as well as contour lines. After the monochromatic underpainting is done, add local color in thin layers.

3. The Mosaic Approach
Begin by dividing the painting into a few large, abstract shapes. Gradually subdivide into smaller and smaller shapes. Avoid placing details until the final stages of the painting.

4. The Scavenger Hunt Approach
Begin by painting the focal point of the painting. Gradually add the elements that surround it until the whole image is complete.

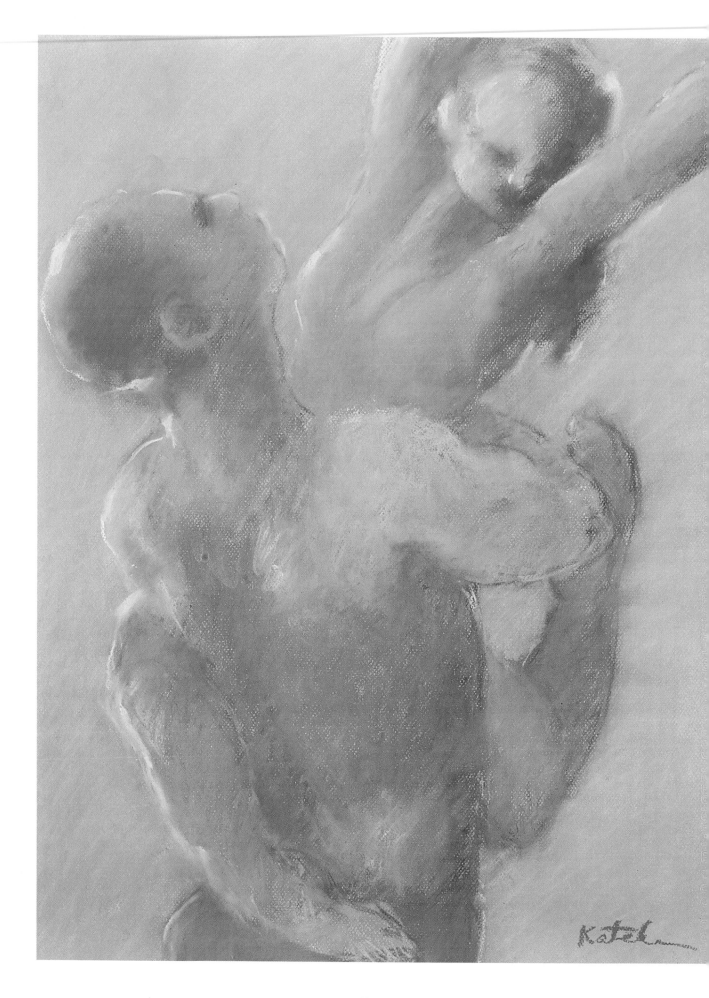

110

DON'T LET A MISTAKE STOP YOU IN YOUR TRACKS.
LEARN HOW TO FIX IT INSTEAD SO YOU CAN MOVE
AHEAD TO A FABULOUS FINISH.

What you need to know about fixing mistakes

Nearly every artist I know agrees that starting a new painting is the fun part. Each sheet of paper seems to bring a new opportunity for success. You forget all the old frustrations and disappointments in the excitement of this new idea. You block it in. The first lines and colors go on easily. You continue to work, defining and refining. The painting is looking good. You are finally achieving what you always wanted in an image. Then something suddenly goes wrong. It can be just one stroke, but it is enough to change the mood, unbalance the composition or destroy the color harmony. In an instant, you go from exhilaration to despair. It happens to almost everyone, over and over again.

The biggest obstacle to working freely with pastels is the fear of making mistakes and not being able to correct them. Relax. I have never seen an error in a pastel painting that couldn't be repaired.

Relax — you can fix it!

Perhaps an artist's greatest challenge is getting past that dark, muddy period, when the original excitement is gone, something is wrong and you don't know how to get back on track. The most important thing to remember at that moment is: Don't panic!

The temptation is to do something — anything — hoping that it might solve the problem before you even know what the problem is. Don't do it. This is the moment to stop, make a cup of tea, pull up a chair and just look at the painting. In almost every instance, the key to completing a painting successfully is taking at least as much time to look at and think about a painting as you spend applying color.

I can't repeat too many times my belief that there is nothing you cannot fix in a pastel painting.

Choose the best option for correcting mistakes

Once you find the mistake, there are many ways of making changes with pastel. Here is my arsenal of weapons for dealing with mistakes:

1. Paint over the offending area with another color.

If the pigment is already thick on the surface, you may have to use a softer pastel to cover it. I have seen very few marks that couldn't be hidden with a heavy stroke of Schminke or some other really soft pastel.

2. Brush or wipe off the wrong color.

I keep a stiff-bristled brush handy for removing small mistakes. This even works well on paintings on sanded surfaces. The bristles reach into the tooth and lift out the pigment. For smoother surfaces, I can often wipe the pigment away from a small area with a paper towel or my hand. The paper towel will remove more pigment. A hand or finger will tend to blend what is there. Try both to see how they affect the problem.

Revising an image
When I first completed "Adagio" (25 x 19" or 64 x 48cm), it included both dancers' entire bodies. I decided it wasn't intimate enough, so I wiped off the surface with a paper towel, sprayed it with fixative and repainted. I am much happier with the close-up version and how it emphasizes the interdependence of a dance partnership.

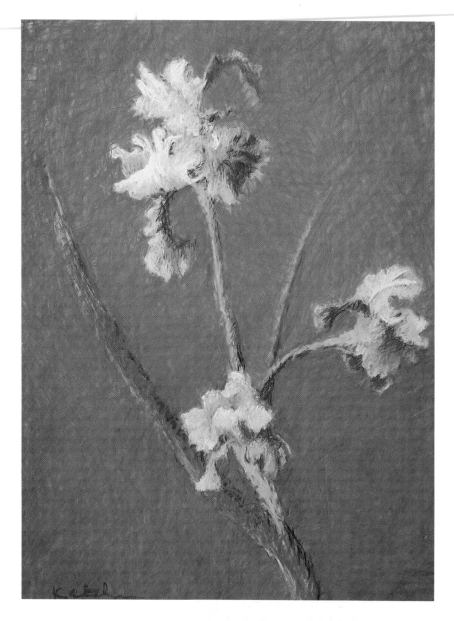

3. Erase the color.

If you have a thin layer of pigment, you can erase a small area of unwanted color with a kneaded eraser. Make sure that the eraser is relatively clean (knead it to eliminate unwanted pigment) or you will be adding whatever color is already on the eraser.

4. Blend the color or line with what's around it.

This is good for small areas that seem to pop off the painting because they are too dark, too light or too bright for what is around them. Use a fingertip or drawing stump to lightly blend.

5. Wipe out the whole painting with a paper towel.

This is the technique I use when the whole painting is going completely wrong. Wiping out reduces the painting to an abstract layer of color that can work nicely as an underpainting. It also removes enough pigment to restore the tooth so that I can work over what's there more easily.

6. Wash off the surface.

Spraying the surface with water works well if you are painting on watercolor paper, Masonite or other board that is primed with an acrylic ground. Don't try it on most pastel papers. They are not designed for wet painting, and will buckle or completely fall apart from the moisture.

7. Spray with workable fixative.

This works with either a small area or with an entire painting that you want to do over. Carefully spray the fixative in several light layers. If you unexpectedly get a thick, glossy area of fixative, sand that spot carefully and re-spray lightly. I have also heard of artists spraying problem areas thickly with fixative and dropping ground pumice into the fixative before it dries. Either method should restore tooth to that spot.

Toning down intense color
At first, the background of "Prima Donna" (21 x 16" or 53 x 41cm) was a bright blue-green. It was a great color, but it was so intense that it fought with the flowers. I cross-hatched over the blue-green with a brownish ochre. The color now relates more to the yellows and greens in the flowers and is dull enough to stay behind them.

Solve specific problems

Once you've prepared your surface for a new direction, where do you go? Here's a selected list of common, specific problems and suggested ways to fix them:

The background is too dark

- Paint over the existing color with lighter colored pastel, covering it completely or blending it to a lighter tone.
- Hatch over the existing color with lighter pastel, allowing the previous color to show through. Either leave separate strokes to blend visually or physically blend the area to create a new color.
- Wipe it out and repaint with a lighter color.
- Spray with fixative and repaint with a lighter color.

The painting is too busy

- Wipe out the whole painting to eliminate details and reduce the total image to lighter, abstract colors. Then go back in and redefine the large shapes.
- If wiping out leaves too much pigment to rework the surface, spray with fixative. Then re-establish a basic design of a few large shapes.
- Simplify the most cluttered areas that detract from the focal point by covering them with strokes of a solid color.

An object is in the wrong place

- If the pigment is fairly thin on the painting, hide the object with strokes of soft pastel in the appropriate colors. Then repaint the object in the new location by laying strokes of soft pastel over the existing color.

Putting the focus in focus

When I know there is something wrong with a painting, but I'm not sure what it is, I ask one question: What is this painting about? That's what I did when I first finished "The Starlets Plan Revenge" (21 x 29" or 53 x 74cm). At that point, there were very defined figures in the background, even though the painting was about the women's conversation. Background figures were irrelevant, so I wiped them out with a paper towel, leaving vague shapes that complete the design.

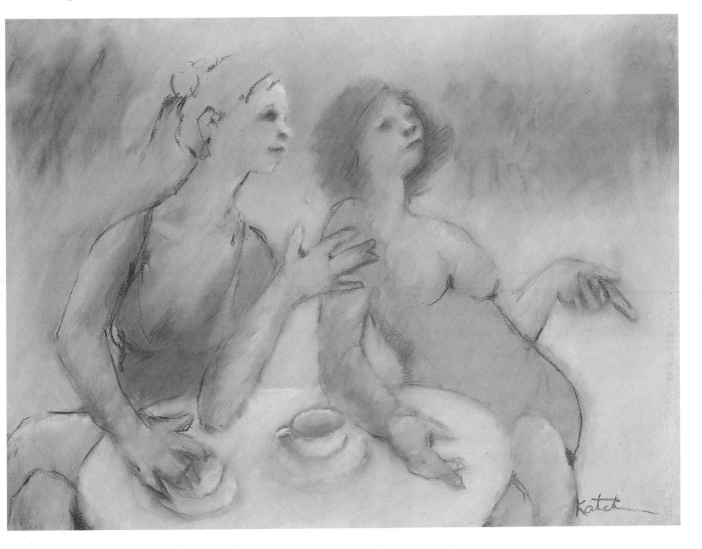

IF YOU FIND YOUR WORK-IN-PROGRESS JUST ISN'T TURNING OUT THE WAY YOU'D IMAGINED IT, STOP. ONCE YOU'VE EVALUATED THE PROBLEM, YOU CAN ALWAYS FIND A WAY TO SOLVE IT

These photos show how, even with careful planning, you can sometimes get to the middle of a painting and decide it needs drastic revision. Fortunately, with pastels, that is not such a big problem.

Deciding on a theme
This was to be a painting of my friend Richard Rackus, one of the finest landscape artists I have ever met, painting outdoors. Seeing him painting outdoors reminded me of the French Impressionists, so I wanted to create a painting that conveyed that feeling. I had several photos to use as reference material. I studied the photos, then made a couple of loose sketches to organize the composition.

Positioning the figure
At my drawing table, I thought I would paint Richard full figure, sitting at his easel under an umbrella, with a view of the California landscape behind him.

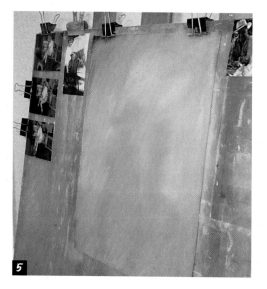

Evaluating the design
At this point, I stopped to analyze my progress. I saw that I had a good abstract design, but the figure was too small in the picture. I wanted to emphasize Richard, not the landscape around him, so I wiped out the whole image with a paper towel.

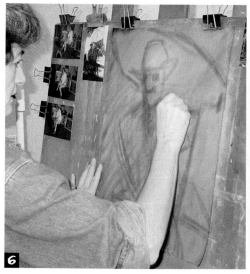

Correcting by eraser
After wiping out, I had a thin layer of grayish pastel covering the paper. I redrew the image, this time focusing more on the artist at work. I was able to draw with my kneaded eraser, pulling off pigment to show the black paper underneath.

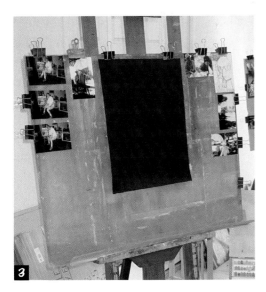

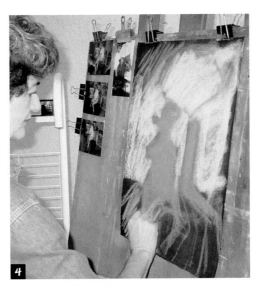

Setting up to paint

Before getting started, I clipped photos, sketches and a clean sheet of paper to my drawing board. Anticipating a fair amount of blending, I chose black Hahnemuhle paper and Unison pastels.

Starting a mosaic of shapes

I laid in the large value shapes. I kept my palette simple, concentrating on the shape and value relationships.

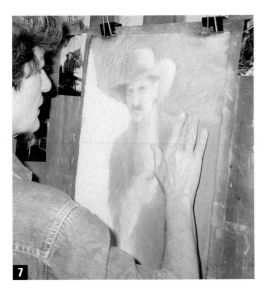

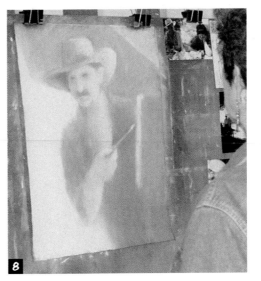

Building and blending

I began to build up color and kept blending, keeping the image soft enough to make adjustments as I went along. I blended the edges between his shoulder, the easel and the umbrella with my fingers so that I wouldn't take off too much pigment.

Stopping to study

This was perhaps the most crucial activity of the whole painting process — stopping and looking at what was there. I stood close to the painting, then backed up across the room so that I could assess what still needed to be done.

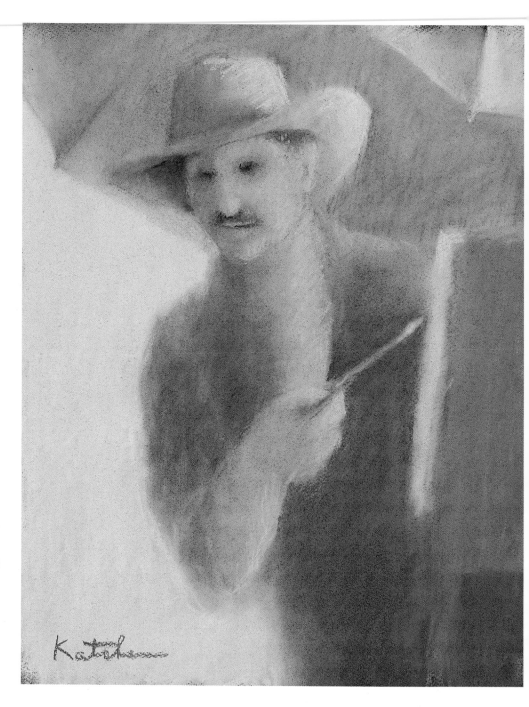

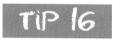

Capturing the look
After a few last strokes, I was very happy with "Painting With the Master" (20 x 16" or 51 x 41cm). It doesn't look like the work of any particular French Impressionist, but it does convey a sense of that era.

TIP 16

When painting faces, I avoid painting the features before I am happy with the shapes of the total face and head. I simply indicate the position of eyes, nose and mouth with a smear of pastel that is slightly darker than the basic skin color. Then, if I want to move or change the features, it's easy to do so.

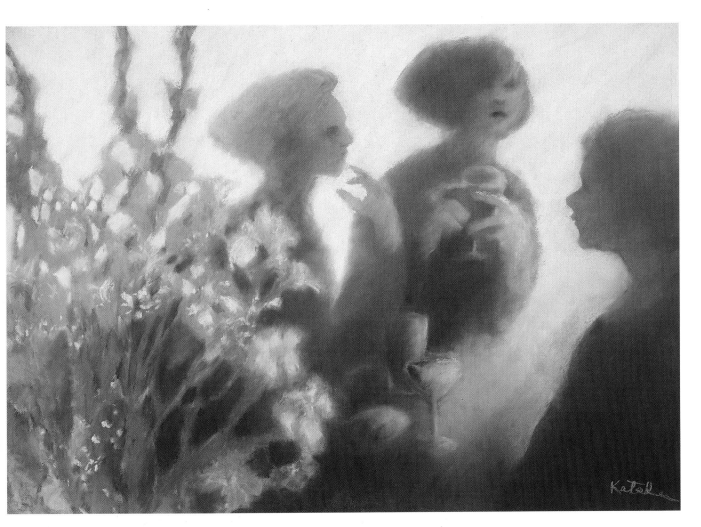

- If the pigment is too thick to hold more color, spray with fixative and rework.

Background objects appear too close
- Choose a stick of pastel that is the complementary color to the objects. For instance, if your blue mountains are too far forward, you will choose an orange hue. Lightly add strokes of the new color over the existing shape.
- Stand back and squint at your painting. The complementary color will have grayed your previous color and moved the object back in space. If you want the shape to move back further, add more of the complementary color.
- When the shape appears to exist where you want it in space, either leave the existing strokes to blend visually or blend the pastels together with your fingers.

The shadows are in the wrong place
- Use one of the same techniques for lightening a dark background.

- Spray with enough fixative to get a workable surface. Repaint shadow areas so they blend in with the rest of the painting. Add new shadows in more appropriate locations.

The highlights are in the wrong place
- First, try spraying with fixative. The fixative might darken the highlighted areas enough so that they are no longer a problem.
- If they are still too light after you spray, repaint them with the desired colors in the correct locations.

The head is too big
- If the pastel is fairly thin, you might be able to cover the outer edges of the head with new strokes of the same colors as your background, thus making the head shape smaller.
- If the pastel is too heavy to hold more strokes, spray with fixative and rework. You may have to rework the facial features in the same way.

Creating depth
At first, the figures in "Texas Roses" (27 x 39" or 69 x 99cm) were as defined as the flowers. It made everything appear to be on the same spatial plane. By blending out the details in the figures, I moved them back to a plane behind the flowers.

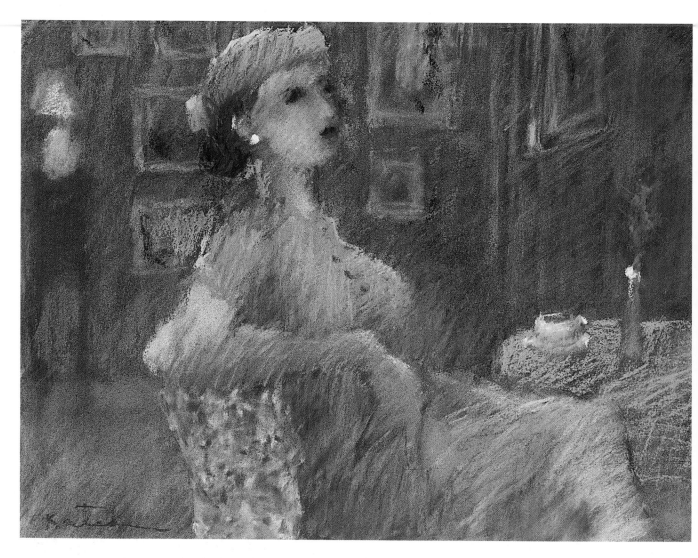

Dressing up a subject
"In the Salon" (11 x 15" or 28 x 38cm) started as a figure study of a nude model in the studio. I liked the pose, but as a painting, it was rather stark. I sprayed it with workable fixative and added clothes and an appropriately neutral background of complementary colors that keeps it comfortably in the back.

The head is too small

- Wipe out the head shape and the surrounding negative space. Either repaint directly on the wiped-out surface or spray with workable fixative if you need more tooth.
- If you have already put in the eyes and other features, they might be so dark that they will show through later layers of color. Spray with fixative. Repaint the face shape as a solid, abstract form. Re-spray lightly. Then re-define the facial contours and features.

A large section of the painting is the wrong color

- If the existing color is related to the desired color, you might be able to mix a new color by adding strokes to what is already there. For instance, you made the dress yellow, but it would be better orange. Adding

strokes of red will turn the yellow area orange.
- If the existing color is totally unrelated, use the techniques for getting rid of a dark color. Brush or wipe out the bad color, spray lightly with fixative and repaint the area. If you don't stabilize the bottom color with fixative, it will blend with the added color, probably giving you a grayed-out, unpredictable color.

The painting is a total disaster

- Wipe it out with a paper towel. If you like the design and pigment that is left on the paper, use that as the basis of a new painting.
- If you dislike even the ghost image of your painting, spray it with fixative and turn it upside down. Use the remaining color as an abstract underpainting for your next attempt.

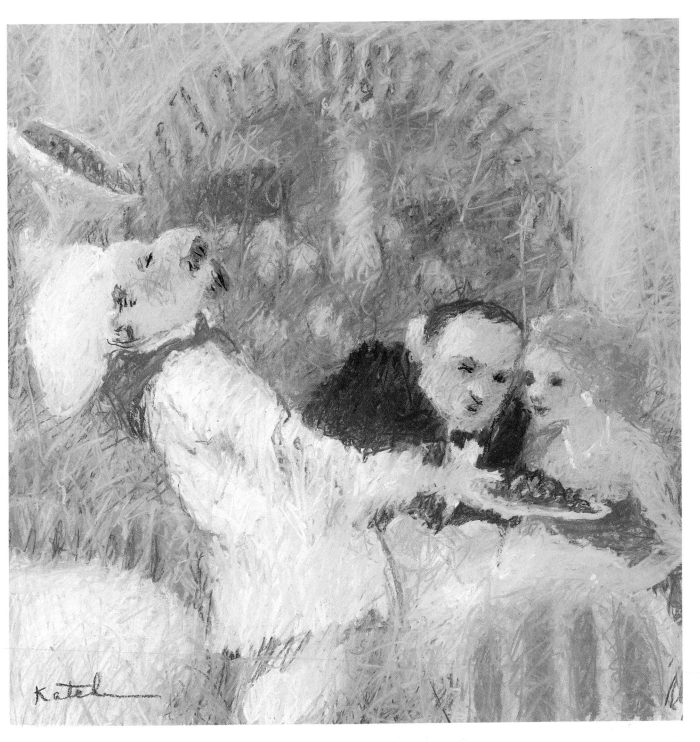

Integrating front and back
Achieving the right balance between foreground and background
was quite a challenge with "High Drama in the Fountain Room"
(18 x 18" or 46 x 46cm). It took many layers of pastel and fixative
before I arrived at value and color relationships that worked.

MOST TIMES, YOU CAN MAKE AS MANY REVISIONS AS YOU NEED TO GET A PAINTING RIGHT

With the right materials, you can usually re-work a painting as often as you need to until you're satisfied with the image. In this case, I had worked on the rough side of a sheet of Canson Mi-Teintes, which is substantial enough to take some abuse. After wiping, the surface still had plenty of tooth to hold pastel.

Dubbing a painting "boring"
After completing this painting, I decided it was boring. I let it sit for a while, then wiped it out with a paper towel.

Working through the revisions
Using the remaining color as an underpainting, I began to add more figures. I had no plan, so I found myself wiping out and repainting periodically. I sprayed with workable fixative a few times to restore the tooth. Eventually, I completely obliterated the first figure. The second and final version of "Geisha Secrets" (29 x 21" or 74 x 53cm) is a much more interesting painting.

TIP 17

After you look at a painting for a long time, you lose your ability to see it objectively. You know there is something wrong with the image but you just can't see what it is. There are several tricks to change how you see a painting:

- Look at it in a mirror.
- Turn it upside down.
- Put it in a frame.
- Hang it on a wall.
- Look at it from a distance.
- Put it away and look at it after some time passes.

Bringing out the fantasy
I believe everyone needs a bit of romantic fantasy. I kept reworking the costumes, background and facial expressions in "Ice Cream Social" (17 x 19" or 43 x 48cm) until they conveyed that lightness of spirit.

REFRESHER COURSE
MAIN LEARNING POINTS IN THIS CHAPTER

There is no mistake you cannot fix in a pastel painting.

Techniques for correcting mistakes:

1. Paint over with another color of pastel. Very soft pastels will cover almost anything.

2. Brush or wipe off the wrong color. A stiff-bristled brush works well on sanded surfaces.

3. Erase the color. A kneaded eraser works well on thin layers of pigment.

4. Blend the mistake into whatever is around it.

5. Wipe out the whole painting.

6. Wash off the surface. This only works on paper or boards that are designed to handle moisture.

7. Spray with workable fixative, then repaint.

LEARN TO USE MY CHECKLIST TO JUDGE WHETHER
YOUR PAINTING IS AS GOOD AS IT CAN BE.

What you need to know about completing a painting

I had been agonizing over this chapter for several days when my sister Linda phoned me. I told her, "I can't seem to explain when a painting is finished". She answered, "You need more jokes".

She was right. The joke is that a painting is never finished. Nearly all of the artists I know have a tendency to want to refine their paintings again and again, even though the paintings seem "finished".

How many times have I put the last strokes on a painting, feeling sure that this was the best piece I have ever done? I've signed it, photographed it and put it in a frame. Then, when I look at the painting later, I see glaring mistakes. I always end up taking it out of the frame and reworking it.

Sometimes I have looked at an older painting and realized that I could paint it better now that I have learned more. There is nothing "wrong" with the piece, but I will rework it anyway because I can now make it a stronger statement.

I heard a similar story about Richard Schmid, one of America's top artists. A dealer who regularly showed Schmid's work told me that one day Schmid walked into the gallery, lifted one of his beautiful landscapes off the wall and walked away with it. Some time later he returned with the painting; the entire foreground was re-painted.

Beware the myth of perfection

You may think the answer to the question "How do you know when a painting is finished?" is "When the painting is perfect". Now, most artists I know would never have the arrogance to claim they had produced a perfect painting or ever could, but we all want to believe that someone could.

Truth is, there has never been a perfect painting. There are paintings that are brilliant, breathtaking, awe-inspiring, but no painting is ever perfect. I remember going back to the Metropolitan Museum in New York to see the Degas paintings again. It had been several years since I last saw them. During this time I had been working very hard on my own art and I had noticed a giant leap forward in the refinement of my draftsmanship. Now, when I looked at the paintings that had previously rendered me speechless, I noticed that there were problems with the draftsmanship. I was stunned.

With every painting, there is always something that could be improved. Of course, we should all work toward perfection — it's a great banner to keep in front of us. But if perfection is your only standard, you are facing a career of frustration.

Instead of working toward some abstract, unattainable ideal of perfection, I have learned to work toward my best — my own, honest best at any given moment. If a painting is the very best I can do, it is finished, at least for right now.

Knowing when to stop
A painting is finished when it captures an interesting subject and also shows the technical elements of fine painting. For example, some of the painterly qualities of "In the Hotel Lobby" (25 x 19" or 64 x 49cm), opposite, are harmonious colors, dramatic lighting, balanced abstract shapes, three-dimensional depth and vibrant surface textures.

HOW TO JUDGE YOUR OWN ART

One of the greatest challenges you have as an artist is judging your own work. There are four things that can help:

1. ASK IF IT STANDS THE TEST OF TIME

The first and most important test for a new work of art is time. It is impossible to see a newly finished painting objectively until some time has passed. While you are still working on it and immediately after you stop, you still see what it looked like in your mind. You see what you intended the painting to be. The mind has an automatic function that psychologists call closure. It tends to fill in holes. If, for example, you draw a circle with broken lines, your mind will see it as a complete circle. It happens the same way with painting. If you execute the entire face except for one small feature, your mind may fill in that detail as if you had drawn it.

Another reason you may have trouble seeing a newly completed painting objectively is that your mind remembers many stages of its progress. It is difficult to know what it looks like right now as distinguished from what it looked like while you were working on it.

In addition, you want the painting to be done and you want the painting to be great. There is always a tendency to see what you want to see. This makes it hard to see what is really there.

The only way to see your own painting clearly and evaluate it objectively is to put it aside, let some time pass and come back to it with a fresh eye. Turn it face toward the wall or put it in a closet for several days. When you come back to it, you will be seeing it with a fresh eye. Some other tricks for seeing the painting objectively are looking at it in a mirror, looking at it upside down and looking at it from a distance.

2. ASK IF IT MEETS STANDARDS OF EXCELLENCE

Earlier in my career, when I began to be regularly asked to write about art and to judge art exhibits, I decided I needed a standardized guide to excellence in painting. I came up with several components of a painting, which are still the categories I use to assess my own and other artists' work. I call this my "objective checklist":

Design
One thing that strengthens a painting is a unifying design. The most effective compositions I've seen rest on a division of the format into three or four large, interesting shapes. The negative space or background is just as important to the painting as the subject.

Balance
This is also essential in design. The composition is balanced if no part of it seems to be falling out of the frame. Sometimes a dark or brightly colored section will make one side of the painting seem heavier than the other. This can be balanced by adding something of similar visual weight on the other side.

Dynamic composition
As the artist, it is your responsibility to catch and keep the viewer's eye. A dynamic composition will help by moving the eye within the art. A strong focal point grabs the viewer's attention. Secondary focal points, directional lines and dynamic shapes keep the eye moving within the image.

Color
A crucial aspect of color is harmony. This can easily be achieved by limiting your palette and repeating colors throughout a painting. Color harmony by itself isn't enough for a great painting. The color must also be interesting. I always look for the use of imaginative or unpredictable colors.

One of the common pitfalls of pastel painting is using all brilliant colors. A painting is most vibrant when there are some grayed colors to contrast with the pure hues. Grayed colors are made by blending one color with its complement.

Surface texture
Surface texture is automatically created by the texture of the paper and the type of stroke you use. Many of the best pastel paintings leave unblended strokes of color to blend visually. At a distance the colors look smooth, but up close the viewer can observe the individual strokes.

Totally blended surfaces work well for some subjects, but without surface texture, there must be other elements in the painting to provide visual drama.

Values

The primary source of drama in a painting is the contrast in tonal values. The greatest impact occurs when you place extreme light values against extreme dark values. For realistic painting, you should have a full range of light, medium and dark values.

Another value consideration in realistic painting is light source. Whether there are one or more sources of light on your subject, the highlights and shadows should be consistent throughout the painting.

Perspective

Some decorative paintings are intended to look flat, but most subjects depend on the illusion of spatial depth. Here are some principles to help create that illusion.

- Objects appear larger in the foreground; smaller in the background.

- Details are more visible in the foreground.

- Edges are sharper in the foreground; softer in the distance.

- Colors are brighter in the foreground and more grayed in the background.

- Value contrast is more intense in the foreground. The lightest lights and darkest darks appear in the foreground; they all turn into middle values as they recede in space.

Draftsmanship

Drawing well is the most important skill for realistic painters. There is just no way to hide bad drawing. Throughout the centuries classical art programs were built on drawing. For the first years of study, artists were allowed to work only with charcoal, mastering line and shading before they could even think about color. Art programs are less disciplined today, but the wise painter still learns to draw first. Nothing detracts more from a portrait than badly drawn eyes or hands.

Sometimes distortion or abstraction can add to the meaning of a painting, but the distortion should be deliberate, not simply the result of not knowing how to draw.

Subject

An unusual subject always makes a painting more interesting, but it's also possible to make a great painting of a common subject by presenting it in a fresh way.

Mood or atmosphere

When I look at a painting, I want to feel some emotion. Mood or atmosphere usually results from a combination of color, lighting and point of view.

Expression of the artist

I am always thrilled to look at a painting and feel that I am looking at the subject through that artist's eyes. The artist's personal vision shows up in the choice of subject, the point of view and the application of paint. It usually reveals a strong enthusiasm or passion. Two other words that come to mind are authenticity and courage. I'll deal more thoroughly with this concept in the last chapter of the book.

3. ASK TRUSTED ADVISORS

Even after you have spent time away from your new painting and you have assessed all of its component parts, you still might not be confident that it's done. When this happens to me, I call in a "trusted advisor".

A trusted advisor is not your mother who will tell you that everything you do is wonderful. Nor is a trusted advisor someone who brutally jumps on every little thing that could be better. A trusted advisor is someone who is committed to you and your success, knows enough about art to give you good advice and has the courage to be honest. I have a friend who has a great eye for details. I call him in when I think I'm done with a painting and he says things like, "Are you sure you want to leave the hand like that?" Once he points it out, I see that the anatomy of the hand is off and I fix it.

Some artists form groups specifically to critique each other's work. This can be an excellent growth opportunity. If you are forming such a group, make sure that all the artists are there because they genuinely want to improve their work.

4. ASK YOURSELF WHY YOU PAINTED IT

Even when you have excellent advisors to give their opinion, remember that the final judgment about your painting is yours. Only you know why you are painting. Only you know what you want to accomplish with this painting.

It is helpful to ask yourself, "Why did I do this painting?"

- To please the eye?
- To challenge the mind?
- To touch the soul?
- To get accepted in an exhibit?
- To win an award?
- To please an art dealer?
- To pay the rent?
- To have fun?

Make a list of your own priorities. If you have met your goals or even moved in that direction, then your painting is complete and completed successfully.

Making the most of the medium

One quality I look for in a painting is how well the artist has used the medium. This tiny painting called "Passion Flower" (5 x 6" or 13 x 16cm) is a wonderful representation of pastel, showing smooth passages of color as well as fine, unblended strokes. It also shows off the intensity of pastel color.

TiP 19

Critique groups can be a great resource for helping you improve your work. But some critique groups are less successful than others. Occasionally you will find people who want to criticize other artists' work just so they will feel better about themselves. This kind of pointed criticism ends up harming everyone in the group.

I suggest you set some ground rules when you start your group. For instance, create a format for critical comments. In my workshop critiques, I don't allow anyone to say what is "good" or "bad" about a painting. Every comment must point out either what works in the painting or what could be stronger in the painting. This structure keeps the criticism from becoming personal and it eliminates comments based on individual taste.

Thinking differently

For me, detail is not one of the hallmarks of great painting. I think a painting can be complete without having every detail defined. In this commissioned portrait called "Ann's Precious Angels" (23 x 23" or 59 x 59cm), for example, I was more concerned with the personality and gesture than precise likenesses. Fortunately, my clients agreed with my objectives, and they believe this picture looks exactly like the two girls in that respect.

Checking that the design is okay

One of the qualities necessary in an excellent painting is good division of space. When judging if a painting is finished, I always check out the abstract composition. If the design isn't both balanced and dynamic, as it is in "Colorado Wildflowers" (19 x 25" or 49 x 64cm), then it isn't complete.

Thinking in terms of light and dark shapes

Sometimes, the best way to evaluate a painting is to squint so that it becomes nothing more than a series of light and dark shapes. Here is what I see when I squint at "Colorado Wildflowers". Is the composition balanced? Yes. The top shape is larger, but the bottom is heavier in value. Is the composition dynamic? Yes. The shapes of the flowers are interesting and irregular, and they seem to be moving on the painting. These simple evaluations can lead you in the right direction.

On a sheet of pastel paper, draw a series of eight 2" squares. With a hard stick of green pastel fill in the square on the left. Make the strokes heavy and dense enough that the finished square is a bright green. In the next square, repeat the process with the same stick of green, but use fewer and lighter strokes. The square should look green, but not quite as intense as the first. Continue through the seventh square, making each square slightly lighter than the one before it. The seventh square should be a very light green. Leave the eighth square blank.

Turn the paper upside down, so that the blank square is on your left and the brightest green is on your right. Choose a hard stick of red pastel. Fill in the empty square with dense, heavy strokes of red so that the square looks bright red. Now add strokes of red, slightly lighter than the first square, over the light green of the second square. Continue to cover each green square with lighter and lighter strokes of red until you get to the seventh square. That should have a very thin layer of red on top of the green. Leave the eighth square pure green.

Now stand back and look at the eight squares. The squares on either end are pure color. Everything else is grayed color. This exercise will give you a greater understanding of how to create grayed colors with complements, and it will show you how bright pure colors look next to the grayed colors. Use this type of contrast to advantage in your paintings.

127

APPLY THE STANDARD FOR EXCELLENCE

Sometimes, it's so hard to let go of a painting, even though you know it's not your best work. That's how I felt about this one. There were parts of it that I really liked, but other parts didn't meet my standards of excellence. It took me years to get up the courage to re-work it.

VERSION 1
This was not as powerful as it could have been
I had worked for a long time to capture the movement and joy of this dancer. When I got to this state, I was quite pleased with the image. After a while, though, I began to think it wasn't as powerful as I would like it to be. Finally, I decided it wasn't the best I could do so there was no reason to protect it.

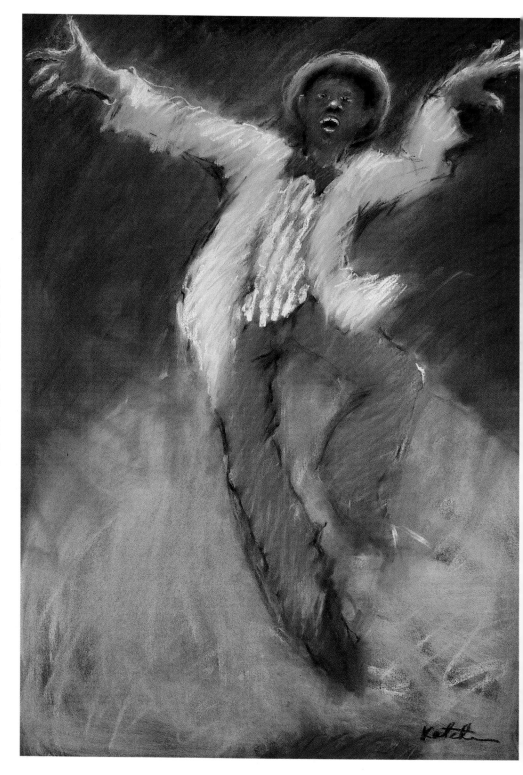

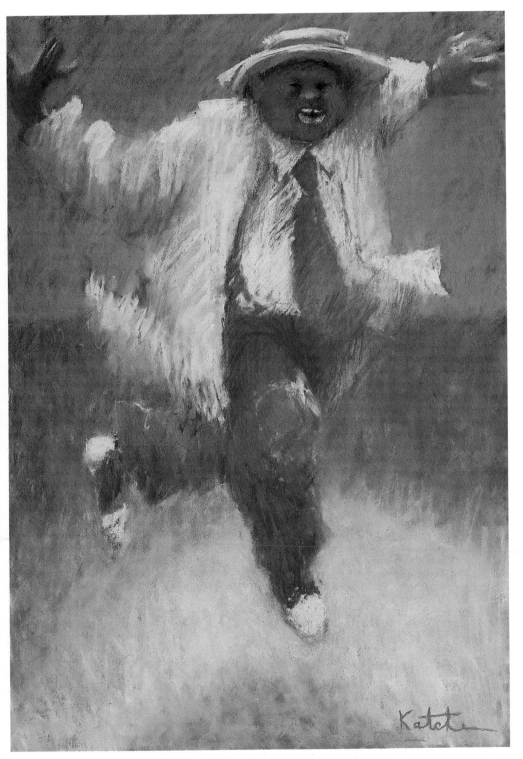

VERSION 2
The painting revisited years later
I lightly wiped out the old image and sprayed with workable fixative. During the years since I had first thought the piece was done, I had learned a lot about color, composition and pastel technique. I used all my new knowledge to take "The Old Hoofer" (39 x 27" or 99 x 69cm) to a much higher level.

**Balancing brights
with neutrals**

An important aspect of color is its intensity. To get the full vibrancy of an image, it should contain the full range from bright, pure colors to dull, grayed colors. Placing strokes of pure color next to grayed colors, as I did here in "Summer in the South" (19 x 25" or 49 x 69cm), will make the bright colors seem even brighter. Notice how I used combinations of complements in these flowers — which are painted almost entirely in greens and reds — to create a range of color intensities.

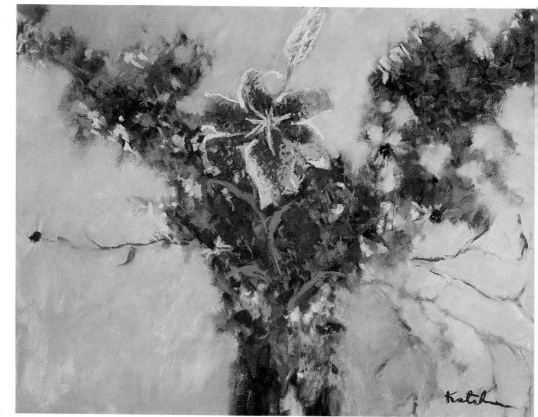

Color grid

One essential skill for an artist is being able to distinguish color from value. The first vertical row (top to bottom) shows the lightest value available of eight different colors. The next vertical row shows a slightly darker value of each of the same colors. Each vertical row gets slightly darker until the last row which shows the darkest values of each color. As you can see, there are no colors that are absolutely dark or absolutely light.

SEEING DARK TO LIGHT

Every stick of pastel has both color and value, and it is important to be able to distinguish those two qualities.

There is a tendency to think that some colors are darker than others. We think, for instance, that blue is automatically darker than yellow, but that isn't necessarily true.

I painted this grid so that you could see the difference.

From top to bottom, each row is a different color. From left to right each of the squares is a different value. You can see here a yellow on the right that is much darker than a blue on the left.

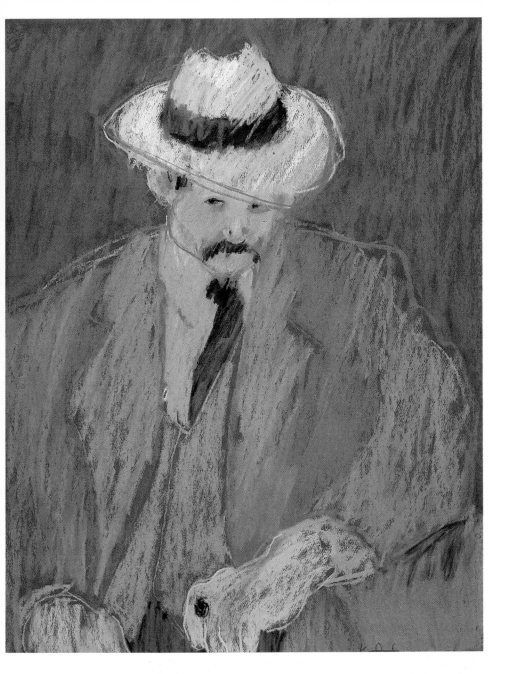

Focusing on what's right

When you assess your own paintings, don't look only for what's wrong. There will always be something wrong. Focus on what makes the painting special. If there is enough good about a painting, it doesn't matter that it has flaws. In "Panama Hat" (25 x 19" or 64 x 49cm), for instance, the figure is flat and the anatomy is distorted. However, I love this piece because of the mood and expression, the spontaneity of the stroke and the freshness of the color.

Making the light consistent

One element that adds drama to a painting is strong value contrast. In "Taking a Meeting" (21 x 29" or 54 x 74cm), I used a single light source to create bright highlights against dark shadows. Especially with a single light source, the highlights and shadows should be consistent throughout the painting — that is, if the light is coming from the right, all the shadows should be falling on the left.

HOW TO USE WHAT YOU KNOW TO CREATE YOUR BEST WORK

Friends of mine opened a new disco called Diva. To commemorate the event, I made a painting just for them called "Presenting the Diva".

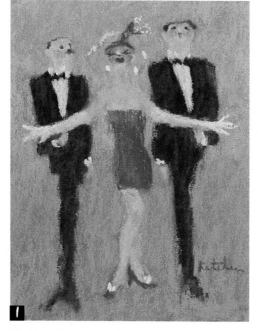

1

Staging the scene

I started with a small color study. This was to be a simple, theatrical image of a diva being presented by two tuxedo-clad men. I decided to leave the background as simple as possible to keep the attention on the figures.

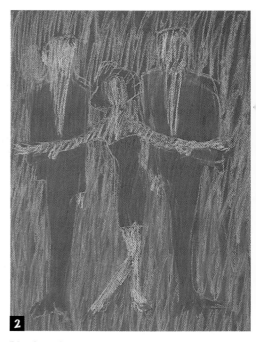

2

Placing shapes

On the rough side of a sheet of brown Canson Mi-Teintes paper, I worked from hard to soft pastels using first Holbein and then Unison. I began with a simple contour drawing to place the figures. Referring to the color study, I blocked in the main value shapes with a range of violets using a loose hatched line. I was more concerned at this stage with shape than exact contours or details.

Strengthening the image

Still using the harder pastels, I solidified color with more hatched layers. Even in the faces, I used quick, loose strokes to suggest facial features rather than define them. I saved the details for the very end. I added green and yellow ochres to move the purple background back behind the figures. At this point, I had stopped referring to the color study as this painting was far enough along to let it take on a life of its own.

3

4

Stabilizing the color

I sprayed the painting with workable fixative. This set the pigment in place and darkened all of the colors.

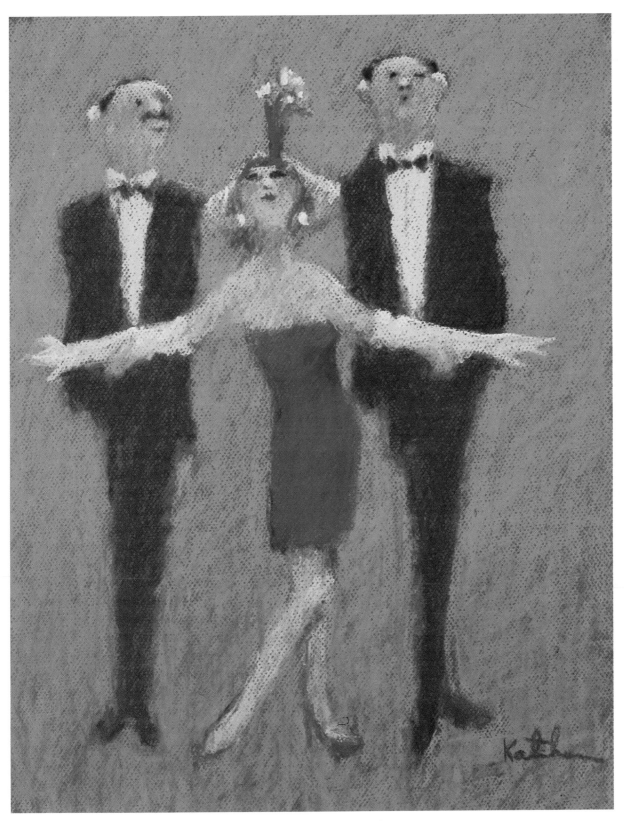

Finishing with soft pastels
Finally, I switched to the softer Unison pastels to create richer,
denser color. I refined all of the contours and placed the final
details in "Presenting the Diva" (18 x 14" or 46 x 36cm).

133

Don't let an unsatisfactory effort nag at you. Set it aside until your subconscious mind finds the best options for refining it. I'm firmly convinced that the best judge of art is time. So when I create a painting and I'm not satisfied with it, I don't rush to find a way to fix it. I let it sit for as long as it takes to reach the best solution.

Deciding on a theme
I started with a simple sketch of a woman on a porch. I liked the juxtaposition of an old person under a flowering tree, the contrast of autumn and spring.

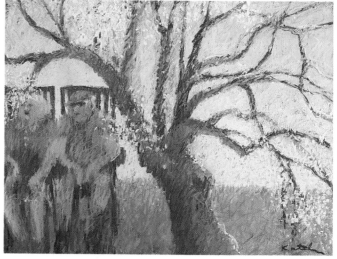

Waiting for the solution
In my original painting, I expanded the image to an old couple sitting in lawn chairs under a flowering tree. When I finished it, I felt there was something wrong, but I didn't know what, so I put it away for a year.

8 THINGS TO DO WITH YOUR PAINTINGS WHEN THEY ARE FINISHED

If you have used high-quality materials, your paintings should be quite durable. However, like all art, pastels need a certain amount of care. Here are a few suggestions.

1. Store unframed pastel paintings flat, painted side up. Cover each with glassine or some other smooth, acid-free paper to protect the surface.

2. Mount pastels with acid-free materials.

3. Protect framed pastels with glass. Plexiglass is less desirable because it generates more static electricity.

4. Use mats and/or spacers to keep glass from touching the pastel surface.

5. Store framed paintings upright or flat with painted side up. Put cardboard between them to protect the frames and glass.

6. Keep them out of direct sunlight.

7. Keep them away from moisture or excessive humidity.

8. When you are handling them avoid jarring movements.

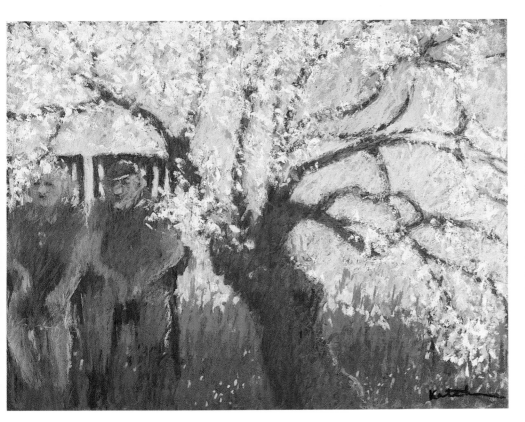

Making simple improvements
When I looked at the painting with a fresh eye, I still liked the subject and composition. However, I felt it could be improved in color and texture. The changes I made to "Old Timers" (23 x 31" or 59 x 79cm) were simple, but they improved the painting a great deal.

REFRESHER COURSE
MAIN LEARNING POINTS IN THIS CHAPTER

There is no such thing as a perfect painting. Rather than trying to be perfect, I suggest striving to do your honest best with every painting.

Four things that can help you objectively judge your own work

1. Time
To get a better perspective on a newly finished painting, put it away for a while and come back to it with a fresh eye.

2. An objective checklist
These are the components of an excellent painting:
- Balanced, dynamic design that unifies the painting
- Harmonious and vibrant color
- Interesting surface texture
- Dramatic value contrast
- Convincing perspective
- Competent draftsmanship
- An engaging subject
- Compelling mood or atmosphere
- Expression of the artist's vision

3. Trusted advisors
It is invaluable to have a person or two who point out to you what will make your painting stronger.

4. Know why you are painting
You cannot know if a painting successfully meets your goals until you articulate those goals.

BE TRUE TO YOUR INTERESTS, PREFERENCES AND
VISION SO YOU CAN FREELY EXPRESS YOURSELF IN
ART. IT'S YOUR GIFT TO YOURSELF AND THE WORLD.

What you need to know about expressing yourself

Self-expression doesn't have to occur in grand gestures. It is there every time you choose a color, every time you make a stroke. It is picking out a subject and deciding what to put in the background. Self-expression occurs every time you do something that pleases you as an artist.

Ultimately, it all comes down to authenticity. You might wonder, how can anyone not be authentic as an artist? Actually, it's quite common. Many of us have spent our entire lives trying to please other people so that we no longer even know what pleases us.

Work for yourself

In workshops, I see artists who have no grasp of their own interests and preferences. One artist uses only diagonal strokes. Why? Those are the strokes his first teacher used. Another artist paints with the colors recommended in a book. Why? She doesn't trust her own judgment. Several artists pick subjects they've been told will sell. This is not self-expression. This is expressing the teacher or the book or the dealers.

Artists who want to find and express their own unique vision have to stop trying to please everyone else. It takes time and it takes courage, but it's the only way to be satisfied as an artist.

Have the courage to let yourself grow

How much time will it take to find your vision? Beginning artists always want to know. I can't answer that — it's different for every artist. Some artists are unique from their very first stroke. Others take years to develop an individual style.

It's more important to think about the process than the amount of time it takes. The joy of being an artist is in the act of painting. It is the magic of putting your own marks on paper to recreate your own vision of the world. You are on an exhilarating journey — the journey of exploring yourself — and if you're lucky, it will take your entire life.

Courage is essential to the artist who is authentic. What you are painting has never been seen before. People might think it's odd. They might think it's ridiculous. They might think it's ugly. I've had people say all those things about my art. What makes it especially painful is that you are being honest. What those people are criticizing is the most personal, the most private part of who you are.

Have courage. You will find people who respond to your work just as I did. When people praise your art, when they buy your art, then it will be the most personal, private part of you that they are validating. That is something worth fighting for.

Be willing to take chances. Be willing to try something you don't know how to do. It is in the not knowing that we find our greatest expression. How can you grow if you keep doing what you already know how to do? Experiment. Explore. Maybe something will happen by accident that expresses what you've always wanted to convey.

Having fun with art
Every so often I do a painting just for the fun of it. "The Eye of the Beholder" (15 x 12" or 38 x 31cm) was one of those. I started with the title. I sat back and visualized two people who are very much in love with each other, but might not seem particularly attractive to anyone else. Like most of the paintings I do "just for fun", this one sold immediately.

TIP 20

Developing your own style is something that happens naturally over time. What helps you develop a style? Painting what you want as you want to paint it. What inhibits your style? Trying to paint like someone else. Don't borrow someone else's style. The world doesn't need to see any more fake Rembrandts, van Goghs, Seurats or Francis Bacons. Be patient. Your own unique style will emerge as you continue to paint.

I remember giving a demonstration during a workshop I was teaching. I was painting a dancer and the more I worked, the stiffer the figure became — with 35 people watching me! Finally I grabbed a sheet of paper towel and wiped out the whole thing. I remember the students gasping. I walked to the back of the room to see what was left on the paper. It was amazing! There was still enough pigment to show the dancer, but with the lines and details softened, he actually appeared to be moving. I took a chance in front of a full audience, and the results were amazing.

Keep money in perspective

What about making money? You may think you have to give up your own personal expression in order to please your buyers and sell your art. But if that's the case, you have the wrong buyers. There are billions of people in the world. Among all those billions, there are people who are looking just for your art. Why give up your vision

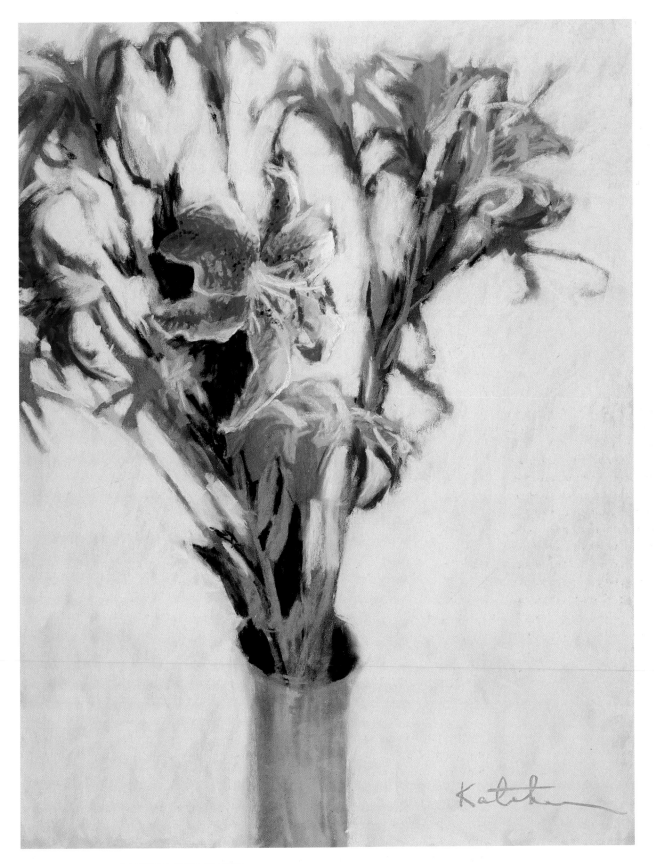

Letting a style emerge

Students ask me how an artist finds an individual style. Style develops naturally as you continue to paint. The way I paint flowers evolved over many years. I have painted hundreds of florals such as "Stargazing" (25 x 19" or 64 x 48cm). For every painting, I studied the flowers and worked on the design of that piece. Gradually, I found the flowers I like to paint and the way I like to paint them.

The greatest impediment to expressing yourself might be the practice of working from photographs. Most artists today rely heavily on photos for reference material. Although it's an easy way of recording information, there are disadvantages to working entirely from photos. The obvious shortcomings are shifts in color or value and loss of detail in the shadows. More important, though, is that shooting photos keeps artists as detached observers. They never have an immediate relationship with the subject because their camera gets in the way. What they are painting is the camera's relationship to the subject, not their own.

In contrast, when you record information in sketches, you become more intimately involved with the subject. You must spend time observing, and during that time you are able to distinguish subtle nuances of mood, gesture, color and lighting. Even if photos seem to work well for you, try using reference sketches to enrich your memory of the subject.

There is a wide belief that if a painting looks like a photograph, it is good. That is not true, but still it keeps a lot of artists trying to paint photos rather than making paintings. Free yourself from the tyranny of the camera. Let your paintings look like paintings. If they are not as slick and precise as a photo, that's fine.

A better approach is to keep a sketchbook. Try painting from your sketches rather than photos.

because some others don't understand it? I said it will take time. It will. And it will take commitment, but if you keep painting the art that you love, you will eventually find the collectors who love it, too.

Meanwhile, what do you do for money? You do whatever you have to do to pay the rent and buy the art supplies without sacrificing your authenticity as an artist. I know lots of great artists who teach classes or design ads or deliver pizzas until their art career will support them. Some of them never work as full-time artists, but the art they do produce is uniquely theirs. It doesn't matter how many paintings they are able to produce, but how special each painting is.

Aspire to be your best

Perhaps the biggest pitfall is comparing yourself to others. We act as if there is somebody somewhere keeping score. Relax. There will probably always be someone who draws better than you, who knows more about technique, who completes more paintings, who sells more, who wins more awards. None of that matters to your own painting.

I am reminded of the years early in my art career when I lived in Denver and Doug Dawson was my best artist friend. How many times I gnashed my teeth because he had won an award from a show I hadn't even been able to get into! What made all the difference was discovering that Doug was feeling exactly the same kind of envy whenever my art was published in an article or book.

There will always be artists who are better at some things than I am, and I am thankful for them. They teach me. They give me something to aspire to. I actively seek out mentors. There are two artists whom I particularly love and admire for their excellence in painting — Pawel Kontny in Denver, Colorado, and Richard Rackus in Ojai, California. After long, full lives as artists, they are still in their studios working toward that next, best painting. It makes all the difference in the world to me to know that I am part of the same noble tradition.

Keep painting your own art. Keep expressing who you are. That is your gift to the world and to yourself.

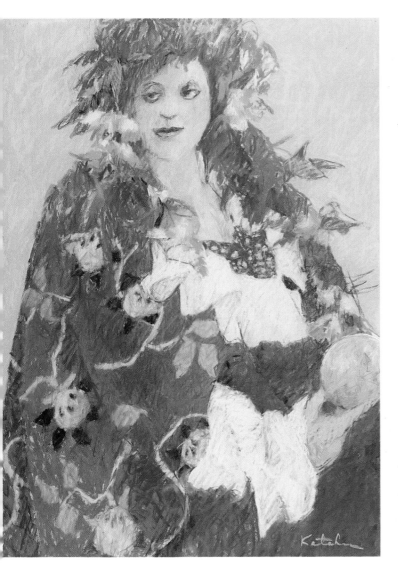

EXERCISE 5: LEARNING WHAT PLEASES YOU

After a lifetime of trying to please everyone else, it is hard to know what pleases you. Here is a quick exercise to help. Take a piece of paper and a pen or pencil into a room where you can be alone. At the top of the paper, write: Things I would paint if no one else was going to see them. Quickly make a list of 10 subjects. Don't show the list to anyone else. Now think about how you might begin to incorporate some of these ideas into your work.

Accepting the imperfections
I have finally given up on perfection. I will never achieve it, and that's fine. In "Goddess of the Springs" (29 x 21" or 74 x 53cm), the proportions and anatomy are definitely not perfect, but so much else is working — color, pattern, texture and the wonderful womanliness of the subject. Who cares if it's not perfect?

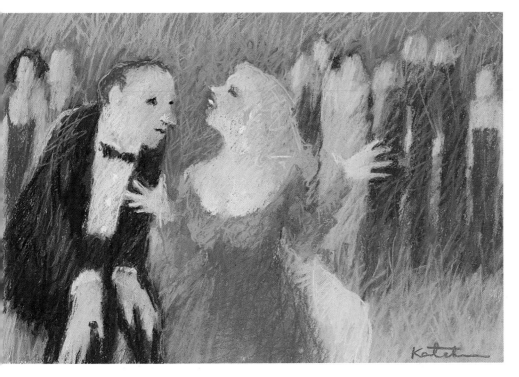

Meeting my objectives
I thought of "Point of Interest" (15 x 22" or 38 x 56cm) as a piece of theater. I started with the female lead taking the spotlight. Then I added her co-star and the supporting players. I wasn't so much concerned about draftsmanship and detail as just getting the story right. As long as the gestures and positioning work, it accomplishes my intent.

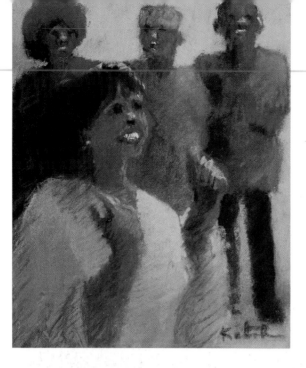

Bringing out the best in me
I live in the Southern part of the
United States, where gospel music
is readily available. One night I sat
in the front row of an impromptu
gospel concert and made sketches
for this series of paintings —
"Amazing Grace", "Swing Low"
and "Tell It on the Mountain"
(all 8 x 7" or 20 x 18cm). I decided
to end this book with them because
they typify what is so wonderful
about the painting medium of
pastels — brilliant color, strong
passion and great joy.

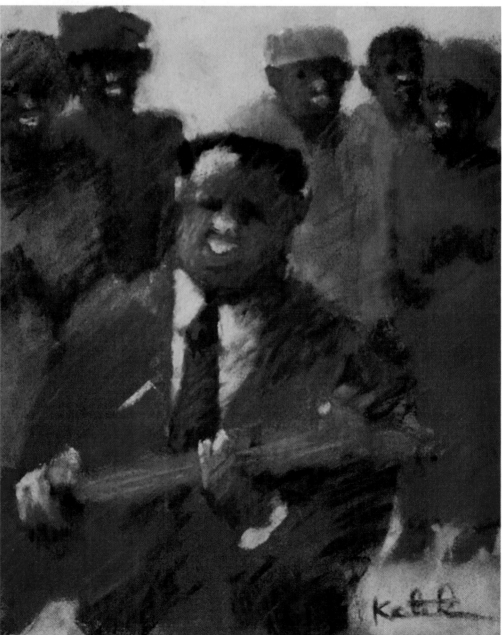

142

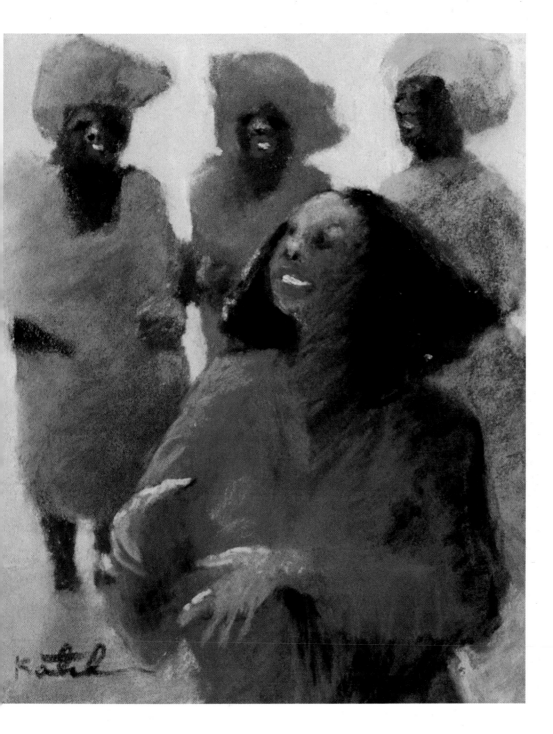

1. Self-expression depends on being authentic, painting what pleases you rather than what pleases other people.

2. Your own unique style will develop naturally as you continue to paint.

3. Self-expression takes courage. Be willing to take chances. There is no growth in continuing to paint what you already know.

4. Don't sacrifice your personal expression because some buyers don't like it. There are other buyers in the world who are looking for your particular vision.

5. Stop comparing yourself to other artists. Your own art is your gift to the world and your gift to yourself.

ABOUT THE ARTIST

Carole Katchen has been a professional artist since 1964, specializing in pastel for most of that time. She has received such prestigious awards as the Avelyn Goldsmith Award, the Grumbacher Gold Medallion Award, the Holbein Award and the Golden Mentor Award from the International Association of Pastel Societies. In 1996, she was designated a Master Pastelist by the Pastel Society of America. Her paintings have been viewed in exhibit or publication on six continents.

She has written 13 previous art instruction books and three children's books. Her previous books include *200 Great Painting Ideas for Artists*, *How To Get Started Selling Your Art* and *Creative Painting With Pastel*, all published by North Light Books. She is a columnist for *International Artist* magazine and has been a Contributing Editor to *The Artist's Magazine* since 1986. She has also been published in *Cosmopolitan* and *Parent's Magazine*.

Born in Denver, Colorado, she currently lives in Hot Springs, Arkansas. Besides painting, she enjoys competitive ballroom dance and singing with the Hot Springs Music Festival Chorus. She is listed in *Who's Who of American Art*, *World Who's Who of Women* and *Who's Who in the World*.

Her art can be seen regularly in several American galleries, including: American Legacy Gallery, Kansas City, Missouri; Bryant Galleries, Jackson, Mississippi, and New Orleans, Louisiana; Legacy Fine Art Gallery, Hot Springs, Arkansas; River Market Artspace, Little Rock, Arkansas; and Telluride Gallery of Fine Art, Telluride, Colorado.